PAINTING COLOR

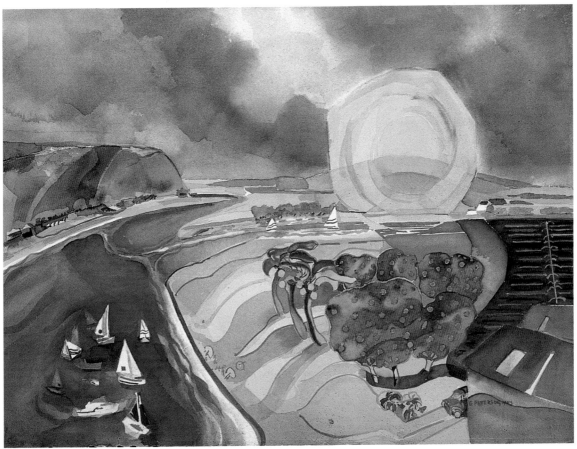

The Orange Belt–*Gloria Paterson*

First published in the United States of America by:
Quarry Books, an imprint of
Rockport Publishers, Inc.
33 Commercial Street
Gloucester, Massachusetts 01930-5089
Tel: (508) 282-9590
Fax: (508) 283-2742

Distributed to the book trade and art trade in the United States by:
North Light Books, an imprint of
F & W Publications
1507 Dana Avenue
Cincinnati, Ohio 45207
Telephone: (800) 289-0963

Other Distribution by:
Rockport Publishers, Inc.
Gloucester, Massachusetts 01930-5089

ISBN 1-56496-349-7

10 9 8 7 6 5 4 3 2 1

Designer: Kristen Webster–Blue Sky Limited
Cover Image: *A Festival,* Margaret M. Martin
Back Cover Images: *(left to right)Apple Harvest,* Oliver Balf
Union Square, Sally Cataldo
Bellavista Night, Michael Schlicting

Manufactured in Hong Kong.

BEST OF WATERCOLOR

PAINTING COLOR

selected by betty lou schlemm/edited by sara m. doherty

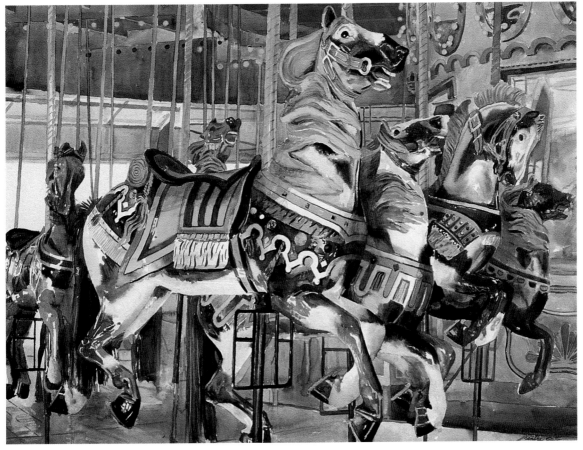

Jumping Pintos–*Sandra Saitto*

Quarry Books
Gloucester, Massachusetts
Distributed by North Light Books
Cincinatti, Ohio

introduction

O f all the design elements, perhaps color has the greatest emotional impact. When we are dealing with color, as with music, we are dealing with sensations. It is not the objects that thrill us but that sensitive, imaginative way an artist puts them together and makes his personal statement in the world of art. Color plays upon form and defines it. It can move far back into the painting and then move forward, bringing into play the picture plane. The pictorial space is created with color: the reds advancing, the blues receding, and the yellows perhaps right at our fingertips.

There are harmonious colors, called analogous colors, which fall close to each other on the color wheel, and there are contrasting colors, called complementary colors, which fall opposite each other on the color wheel. The harmonies give us rest while the complementing colors add life to the painting and give us little jolt.

Value and intensity of color depend on the artist's feelings—color changes as emotions change, and not just the color but their many variations and combinations in value, hue, and intensities. There are the dull, the murky colors that, when put together with those of sheer brilliance, make one color sing and the other becomes a soft humming holding the painting together. The gray subtle washes become rich when a few strokes of brilliant color are dropped into them when they are still wet and together, they work to make a beautiful piece of art.

Color composition is built with one stroke or shape against another until the entire painting is completely balanced. Experience will tell you what color can do. Color should stimulate the imagination. The warm colors, yellows, reds, and oranges, are exciting, but too much of these can leave a feeling of fatigue if used in overabundance. But red, especially when taken in moderation, can add life and lift to the painting. Blues, greens, violets, and soft grays are emotionally restful to us. Perhaps that is why walking through a park or a wooded area can bring such peace to our soul. Merely venturing out under the blue sky with beautiful sunlight is good for man and beast.

Color helps express all of our emotions, and the knowledge of color and its power helps us in the pursuit of creating art. May this book of many paintings, many styles, and many schools of thought reveal each artist's quest in expressing their own personality in their creations with the use of color.

Betty Lou Schlemm, A.W.S., D.F.

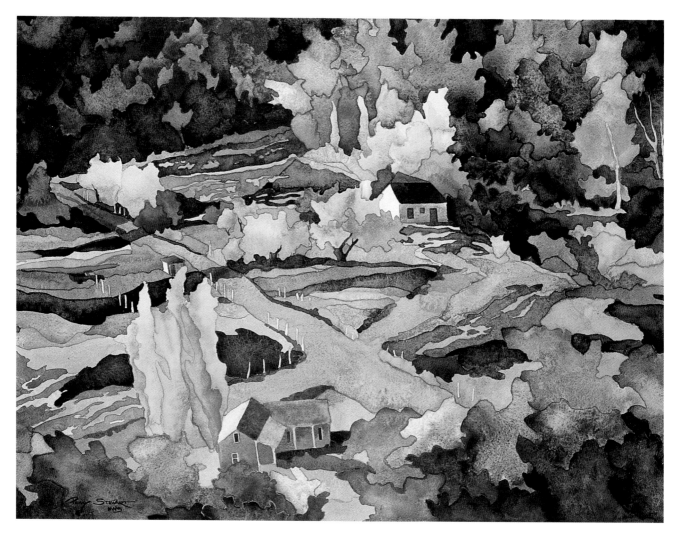

PENNY STEWART
Morning Glory
22" x 30" (56 cm x 76 cm)
Arches 300 lb. hot press

Using the language of color, I captured the beautiful serenity of this sunlit valley in the protective embrace of dark, silent woods. I first painted each foliage shape in its local color, and then added a second hue in the damp paint, enriching its color while suggesting both volume and texture. I was able to enhance the autumn beauty by contrasting light, transparent yellows and oranges with darker, more opaque greens and violets. To create variety and interest, I broke the larger field shapes into bands of green.

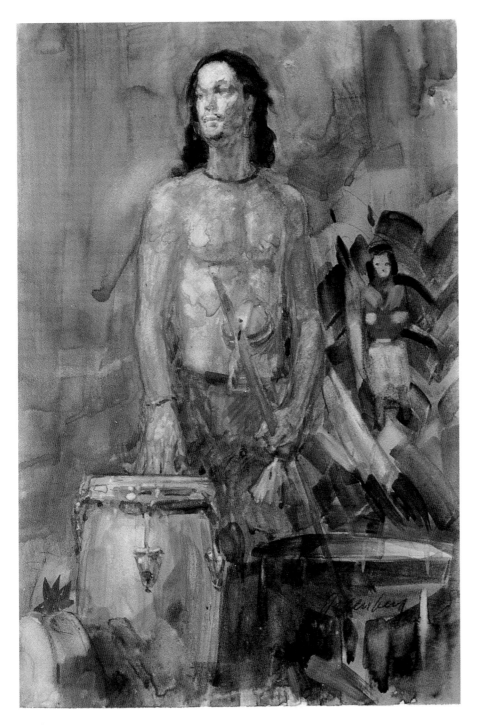

IRWIN GREENBERG
Street Musician
11" x 7" (28 cm x 18 cm)
Bristol 5-ply board

The model, a congo drummer, posed
in my studio under a spotlight. His
skin tone and outfit suggested the
dominant warm color of the painting.
The surrounding props were taken
from sketches and painted to enhance
the warm tones of the figure. The
background was painted with cool
tones, which contrasted with the
warmth of the model and added
vibrancy to the painting.

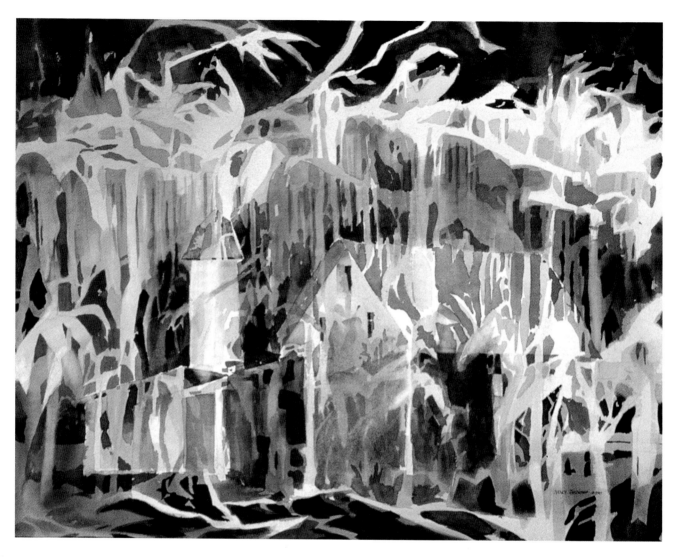

NANCY FELDKAMP
Harvest Ready
22" x 30" (56 cm x 76 cm)
Arches 140 lb. cold press

When planning a painting, I choose a triad of colors to use as a dominant theme and to ensure unity. With autumn's changing palette bringing greater color awareness, I used raw sienna, ultramarine blue, and alizarin crimson in *Harvest Ready* to suggest the season's sun-filled harvest weather. Other colors added accents and gave subtle variety to the shadows and negative areas of the painting. The paper remained unpainted in places to suggest the fields of near-white, ripened corn.

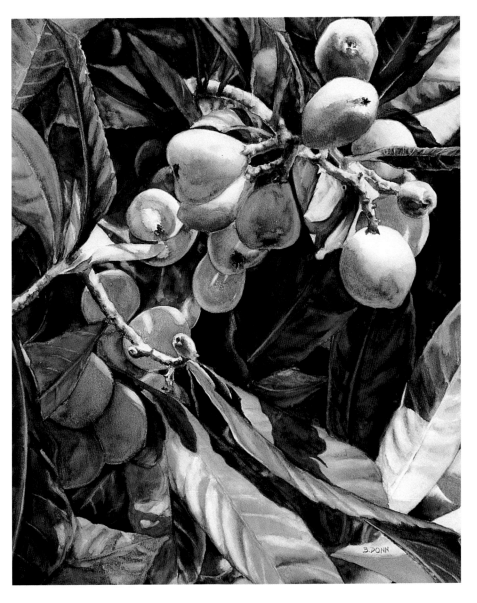

BRIAN DONN
Loquat Cascade
18" x 15" (46 cm x 38 cm)
Canson-Montval 140 lb. cold press

The range of colors of ripening
fruit and the cool, shadowy interiors
between them caught my eye and
offered up the subject for *Loquat
Cascade*. I wanted to capture the
slightly fuzzy texture of the fruits
and contrast it with the thick,
leathery leaves. I was able to
achieve this by painting each
fruit wet-in-wet, lifting out lights,
and then dropping in darker tones.
Leaves were painted on dry paper,
saving the lights and washing away
edges to render the corrugations
and veins. The interplay of colors
was enriched by the light's wide
range of reflection. Cool shadows
were glazed on and exaggerated
to play up every nuance of color
essential in capturing the sense of
fruit ripening in the California sun.

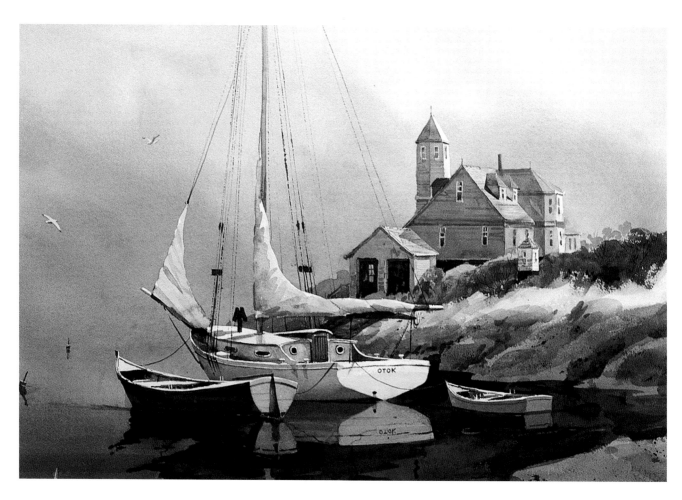

FREDERICK KUBITZ
Sailboat in Fog–Damariscove Island, ME
22" x 30" (56 cm x 76 cm)
Arches 300 lb. cold press

Bold value changes and subtle colors were used to bring out the numerous effects of the subject, which include top-lighting produced by fog-filtered sunlight, and shadows created by a random shaft of direct sunlight. The darkest values were achieved by layering a series of four washes of French ultramarine mixed with raw umber (to modulate the tone). After a wet-in-wet mixture of veridan and permanent rose, cobalt blue was applied to produce a cool, gray, foggy background. The boats, sails, and buildings were masked. Predominantly cool colors were enhanced by light washes on the sail and roofs and dark, warm tones inside the boats.

PATRICIA REYNOLDS
Champlain Valley Patchwork
31" x 41" (79 cm x 104 cm)
Arches 260 lb. cold press

An underlyimg wash of cobalt blue permeates the painting and conveys the cold colors of the winter. I began wet-in-wet, preserving the whites for contrast and drama. I represented Lake Champlain, the foreground valley, and the Vermont mountains across the lake abstractly to give the look of a winter evening. After letting the work dry, I applied thin glazes with a 4-inch wash brush to create the abstract pattern and dimension in shadow-like forms. Glazed patches of color created the feeling of ice, and warm tones in the foreground allowed the cooler areas to recede and establish the proper perspective.

JIM PITTMAN
Wall Marks
30" x 22" (76 cm x 56 cm)
Strathmore Aquarius
Watercolor with acrylic, pencil,
and crayon

Focusing on shapes and color movement, both light to dark and warm to cool, I first laid broad washes of primary color in mid- to light-tones, and then began layering mixed watermedia in a put-and-take approach. Searching for marks that indicated the passage of time and man, I used several techniques until a depth of surface produced lyrical, poetic passages. Some marks are suggestive of ancient times, while others suggested the graffiti of the present day.

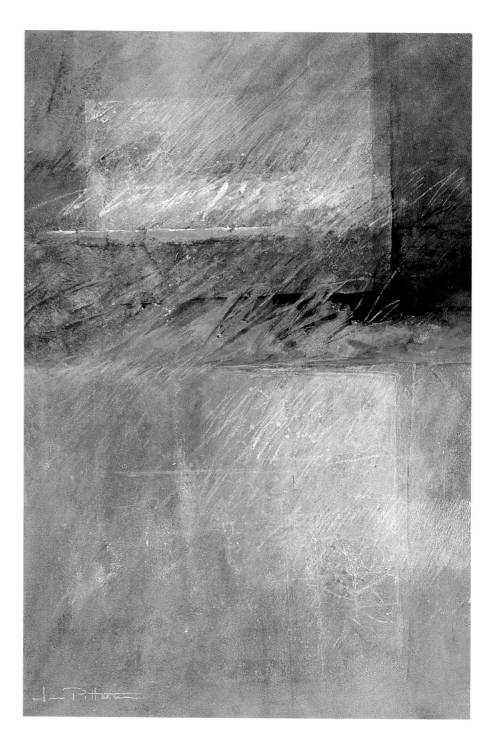

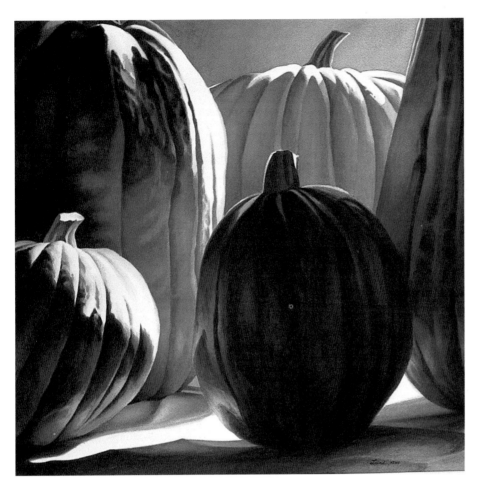

JANET LAIRD-LAGASSEE
Pumpkins No. 22
15" x 16" (38 cm x 40 cm)
Arches 140 lb. cold press

Using color as the essential tool for defining the illusion of form, substance, vitality, and environment, *Pumpkins No. 22* is an exploration of the color and tonality that forms compositional relationships. A seemingly limited palette was broadened to produce numerous variations that were further enhanced by reflected and refracted color. Color was altered and extended through closely graded glazes to create the impression of the pumpkins' solid presence.

LOLA JURIS
Lily Legacy
22.5" x 18" (57 cm x 48 cm)
Arches 140 lb. cold press
Watercolor with ink

Lily Legacy deals with the dichotomy of a scene that is simultaneously exciting and tranquil. The challenge was met by counterpointing the long, slow, quiet shadows of the lower portion with the sharp, dark, upper background. Further, the cool-blue upper area changes to a warm yellow-orange below, and this use of a complementary color scheme augments the drama of the image. Some cool color is charged into the warm shadows, color-connecting the two portions of the painting.

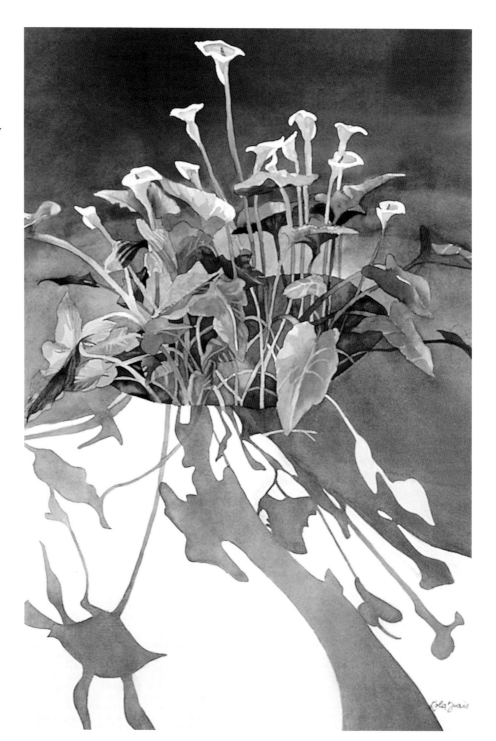

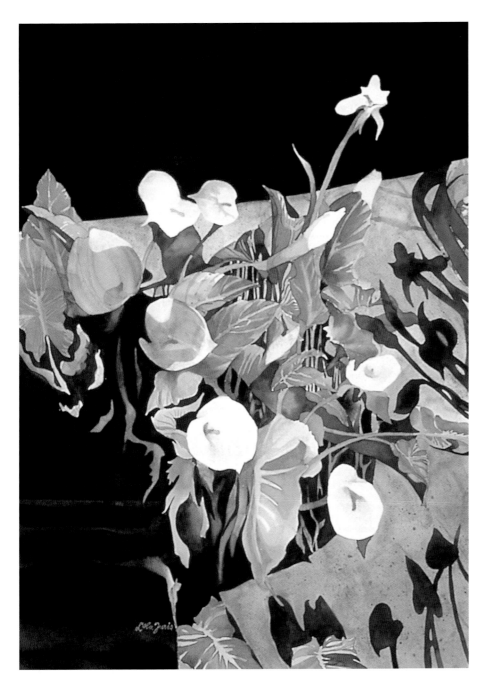

LOLA JURIS
Languid Lilies
27" x 20" (69 cm x 51 cm)
Arches 140 lb. cold press
Watercolor with colored pencil

I paint the calla lilies that grow in a small pool on my patio once a year as an ongoing series. In the late afternoon, long shadows play into the scene and create abstract patterns that counter the realism of the subject. The stately serenity of the white lilies, surrounded by a busy tangle of yellow-green leaves, is further dramatized by the stark background. Touches of colored pencil were selectively added to augment various features and rhythmically move the viewer's eye through the painting.

JAN UPP
Aix Marks the Spot
20" x 20" (51 cm x 51 cm)
Arches 140 lb. cold press

The deep contrast of light and
shadow and the low angle of
perspective attracted me to this
subject. I began by gradually
transferring a full-size sketch to
watercolor paper, starting with
the areas of the paper I wanted to
remain unpainted. A yellow wash
was applied everywhere else,
followed by layers of yellow, red,
and blue to gradually build up the
desired values, leaving the small
details until the end.

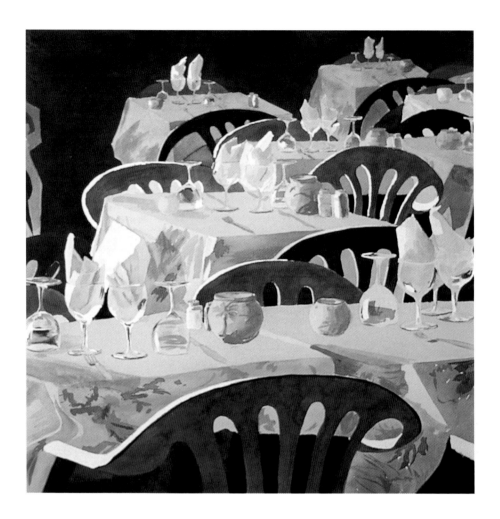

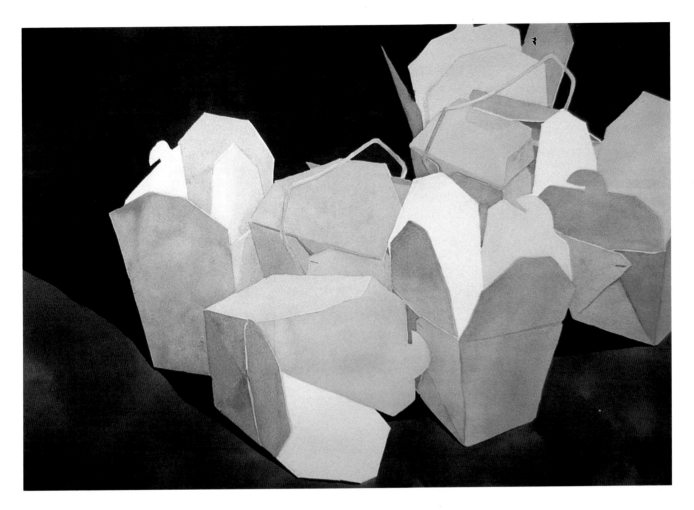

JAN UPP
Dine In or Take Out
20" x 28" (51 cm x 71 cm)
Arches 140 lb. cold press

The many different shades of white caused by the reflections on the box sides attracted me to this subject. The subtle colors were achieved by first applying many layers of pale washes of aureolin yellow and then permanent rose, followed by Prussian blue, repeating the process until the desired color and value were achieved. When one side of a box needed to be a little darker, I applied three more washes on it, one of each primary color; resulting in some areas having as many as fifteen washes. I layered washes rather than mixing the colors because it produces a richer surface variation.

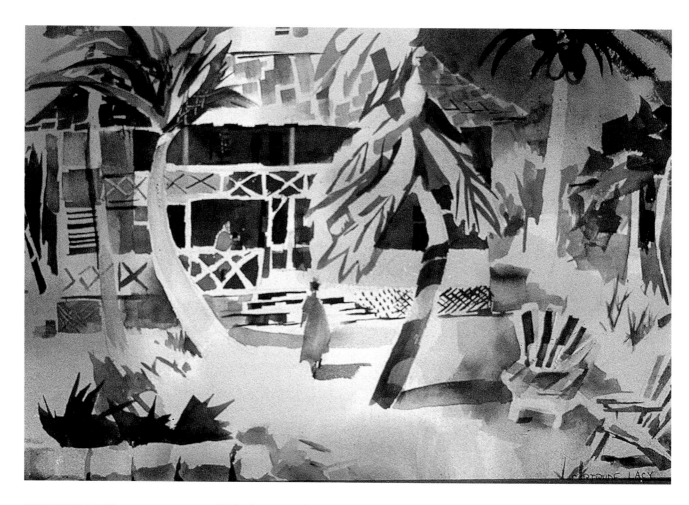

GERTRUDE LACY
Key West
15" x 22" (38 cm x 56 cm)
Arches 140 lb. cold press

While the sun weakens color, intense darks appear in the shade. I began with random blocks of high-key warm and cool staining colors and painted wet-in-wet, leaving an area near the center untouched. After drying, I painted many of the forms negatively, surrounding them with grayed washes of complementary colors. Darker washes in the shadow areas were added, and some calligraphy defined the forms and gave color to the painting.

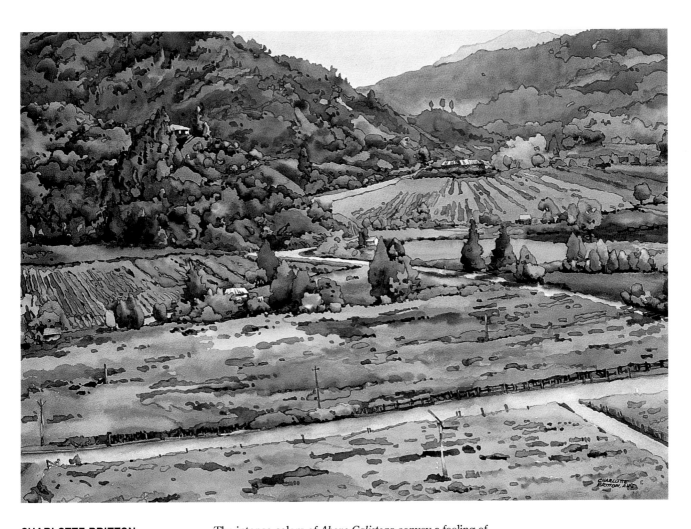

CHARLOTTE BRITTON
Above Calistoga
22" x 28" (56 cm x 71 cm)
Arches 300 lb. rough

The intense colors of *Above Calistoga* convey a feeling of the warmth of the sun on a California vineyard in early autumn. Painting the sky a warm violet further heightened the feeling of heat. Working in watercolor on rough paper, I use color to establish the warmth of the subject.

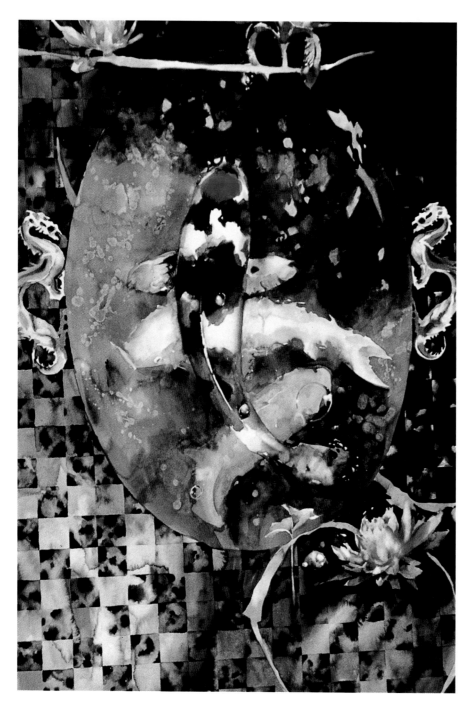

SHARON HILDEBRAND
Space and Illusion
48" x 36" (122 cm x 91 cm)
Fabriano Classico 280 lb. cold press
Watercolor with gold leaf and
Marble Thix

Space and Illusion reflects my
strong interest in Oriental art and
the symbolism inherent to it. The
central koi fish is a prized Sancho
Sanshoku, noted for the red blotch
on its head and its distinct black-
and-white markings. I used gold-leaf
paint on the backs and feet of the
dragons, symbols of nobility and
strength. Darks in the upper right
and subtle use of complementary
colors lend drama to the composi-
tion. The tile color creates a mar-
bled effect, painted wet-in-wet with
mostly darks and just touches of
greens and pinks.

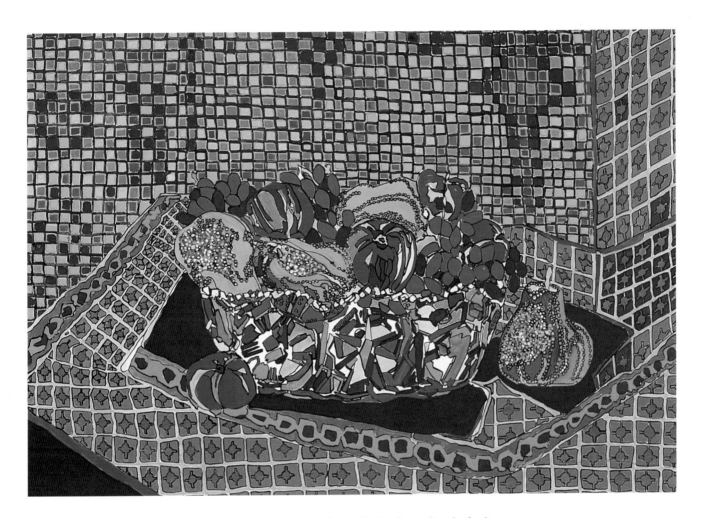

LORRAINE DENZLER
July
23" x 30" (58 cm x 76 cm)
300 lb. hot press
Watercolor with gouache

In painting *July*, I used gouache for the purity of color it provides me. This approach presents a challenge since definition of objects is by use of color rather than value. Colors must agree with those around them and must integrate composition, space, and movement for the work to be successful.

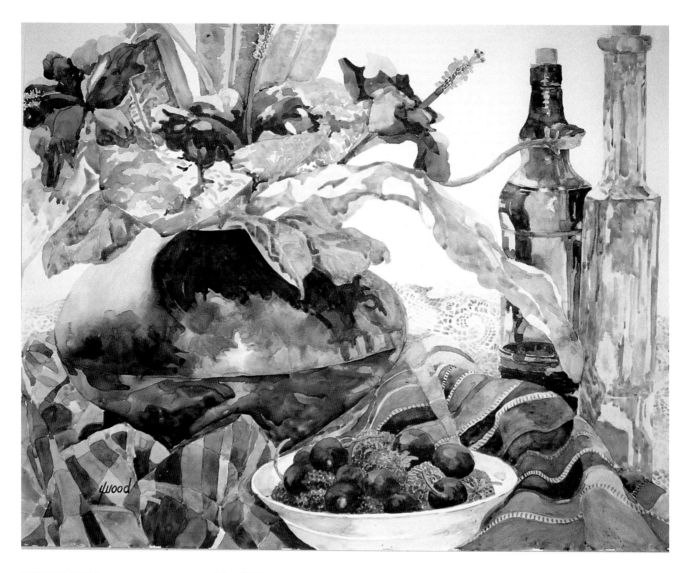

YVONNE WOOD
Glass and Brass Still Life
23" x 29" (58 cm x 74 cm)
Strathmore bristol plate surface

My still life was set up in front of a window to capture the way sunlight shines on the objects. A white background, transparent bottles, and a lace cloth were chosen for their airiness, and the lace's pattern adds an intricate, abstract design. The paper's plate finish allowed vivid colors to run together and stay on the surface, creating colorful abstract patterns. The plaid cloth and colored bottles are reflected in the brass pot, with each reflection painted into tiny pieces to relate to the next object. The dominant presence of red creates a rhythm throughout the painting that brings unity to the work.

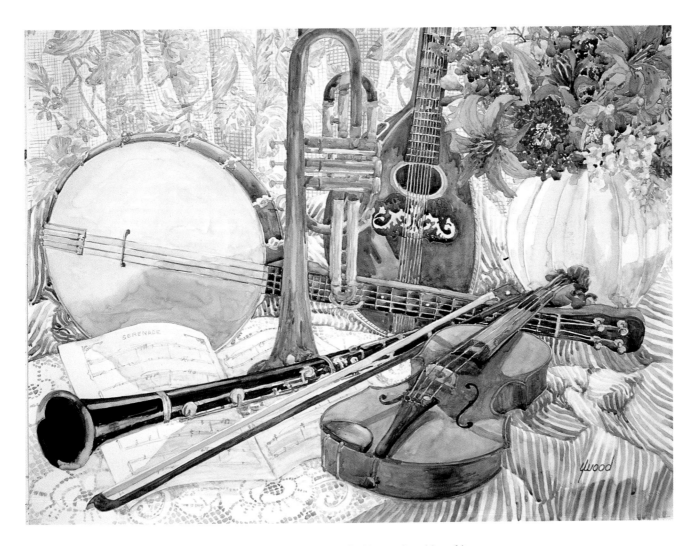

YVONNE WOOD
Musical Instruments Still Life
23" x 29" (58 cm x 74 cm)
Strathmore bristol plate surface

Musical instruments, interlocking and positioned in a triangle, set a rhythmic mood and establish the primary focus of *Musical Instruments Still Life*. Light and shadows cast various patterned forms on the objects. Because of the straight lines of the instruments, I chose striped fabric to give balance to the composition. Lace cloths bring a subtle design and give balance to the white vase on the opposite side. Secondary colors were repeated throughout the painting and color nuances pop in and out. The plate finish of the paper allowed the vibrant colors to stray on the surface.

JORGE BOWENFORBÉS
Mending Sails
22" x 30" (56 cm x 76 cm)
Arches 140 lb. cold press

Every artist has a personal way of seeing and interpreting things in terms of dynamic energy, composition, and shapes. Nowhere in this process is the criteria more manifest than in the use of color. The integration of warm and cool colors present a division of depth and space, besides expressing mood and increasing the emotional impact to the highest level. Since my work is experimental, I have the opportunity to use stronger color contrasts. In *Mending Sails*, the cool, restless aquatic background is enhanced by the warm foreground activity.

MICKEY DANIELS
Yesterday's Antiques
30" x 22" (76 cm x 56 cm)
Arches 140 lb. cold press

I started by preparing a contour drawing of the subject matter and then developed the internal design of each object using a variety of horizontal shapes. Because the theme was recollection of things of the past, orange was chosen as the dominant color to create a warm, nostalgic mood. Each horizontal shape was dampened and floated with color, some with bold, sharp edges, and others with a gentle transition to neighboring white areas. These white areas were left free of masking fluid to allow for freedom of movement. Additional glazes highlight the design structure of the painting and add impact.

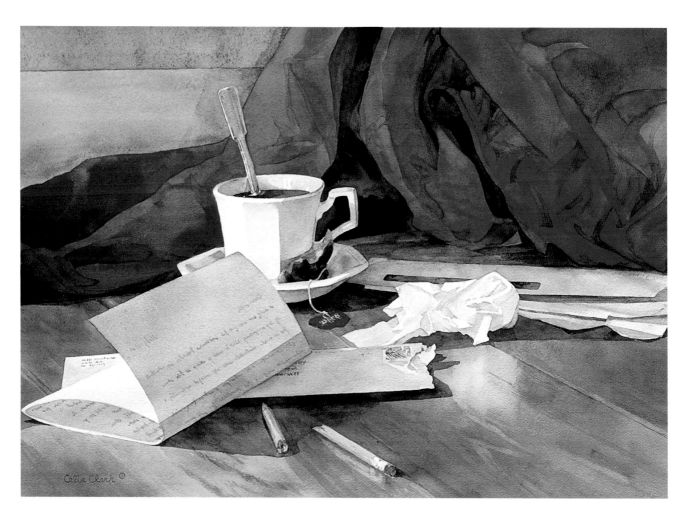

CELIA CLARK
The Rejection
24" x 32" (61 cm x 81 cm)
Arches 140 lb. cold press

Though I usually choose a subject for its color, sometimes, such as in *The Rejection*, the subject comes first and I then determine how color can best express it. In this work, color was used to command attention and dramatize the subject: brilliant red was chosen for the anger and frustration it suggests. I chose warm colors over somber colors to imply that a rejection need not be devastating. For richness and vibrancy, I used lightfast colors and mixed them directly on the paper, beginning with washes to set the tone, then building on these with layering.

CHRISTINE M. UNWIN
Moon Rise—Out West
22" x 30" (56 cm x 76 cm)
Arches 140 lb. cold press

Instead of playing single notes of color, I like to paint chords of color because of the many subtle variations it creates. Color is a personal expression: I don't feel limited to paint only local color, I am free to develop colors according to my mood. Color experiments are a continuous process throughout an artist's life, and I try to surprise the viewer with my choice of colors. I love to use bits of pure color right out of the tube as an accent, with these jewel tones proving especially effective when used against neutral, muted colors.

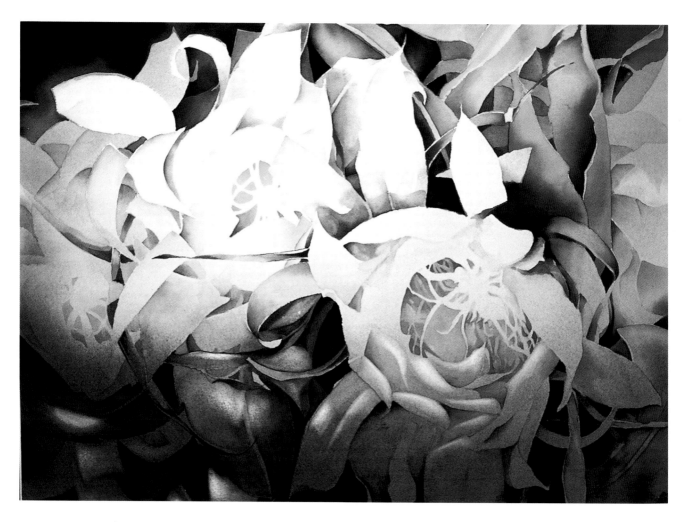

DAVID MADDERN
Cereus in Moonlight
22" x 30" (56 cm x 76 cm)
Arches 300 lb. cold press

The cereus blooms only after nightfall and closes with the first light of dawn. Its extreme delicacy and fragrance permeates the red-black Florida nights. Having studied music, I try to apply music principles to the realization of a painting, besides emotion and intuition. After laying a pale, graded transparent wash, I drew the cereus. The feeling of form, color temperature, melodic themes, and fragmented motifs evolved as I painted. Positive light shapes were glazed with non-staining colors, while the darker negative areas were mainly Winsor green, carmine, and Antwerp blue, mixed directly on the damp paper.

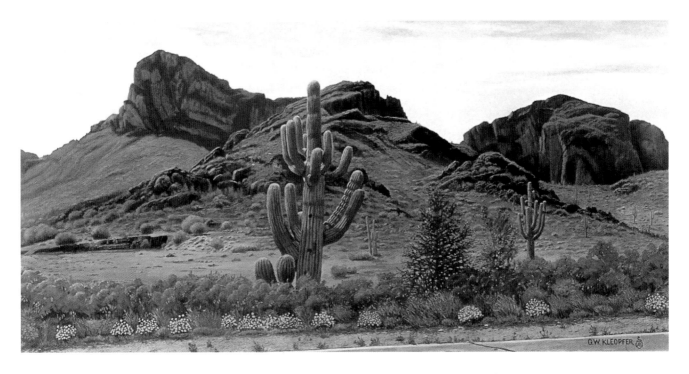

GEORGE W. KLEOPFER, JR.
Thar's Green in Them Thar Hills
16.5" x 32.5" (42 cm x 83 cm)
Double thick illustration board
Watercolor with acrylic

Having driven by this scene many times, never before had I seen it clothed in such uncharacteristic brilliant shades of green. An unusual amount of rain brought a seldom-seen freshness to the color of the landscape. Color became the basis of this painting in order to capture the essence of the scene. Extreme value changes made possible the feeling of spatial distance. I worked with acrylics to achieve many effects otherwise unattainable with gouache.

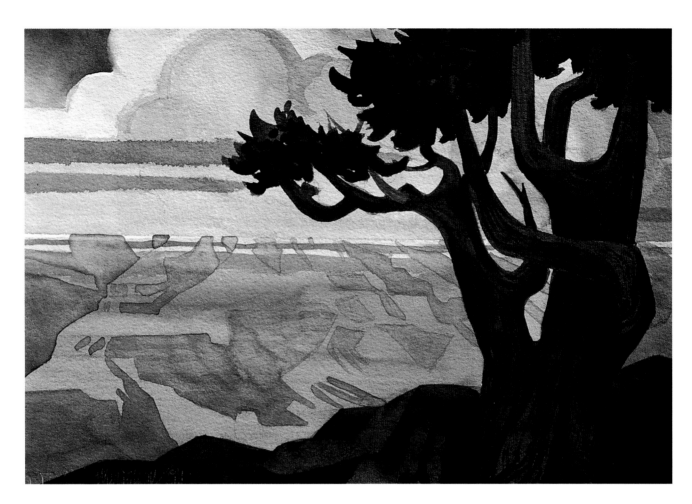

JOANNA MERSEREAU
Canyon Glory
11" x 15" (28 cm x 38 cm)
Arches 300 lb. cold press

I think in terms of color and how it can be used to most effectively dramatize a subject. In *Canyon Glory*, I used a spotlight effect in which the canyon is bathed in warm color, accentuated by the cool foreground tree and rocky ground. The painting was created by applying glazes of transparent watercolor, using deeper, saturated colors in the foreground.

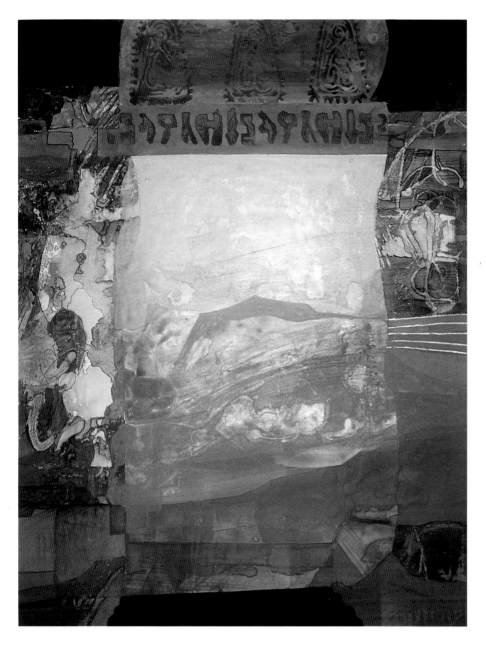

DELDA SKINNER
Dialogue
26" x 20" (66 cm x 51 cm)
Crescent 110 illustration board
Watercolor with acrylic and pencil

Dialogue is about communication between all cultures, with color serving as the universal link between them. I have developed my own alphabet and symbols and use them in hand-carved stamps with the emphasis on color. By using watercolor and acrylic paints, I get a clarity of color that is unequaled in other mediums. Layering colors achieves many variations, hues, tints, and values that cannot be painted in any other way.

LINDA S. GUNN
The Pan
22" x 15" (56 cm x 38 cm)
300 lb. hot press
Watercolor with liquid acrylic ink

The Pan was taken from photographs and sketchbook notations I had taken of the Peter Pan statue in London. Contrasting color adds drama and leads the viewer into the painting. The yellow light casts a warm glow on the statue and creates a striking contrast with the deep blue sky. The use of red in key areas of the statue adds warmth not found in the original photograph.

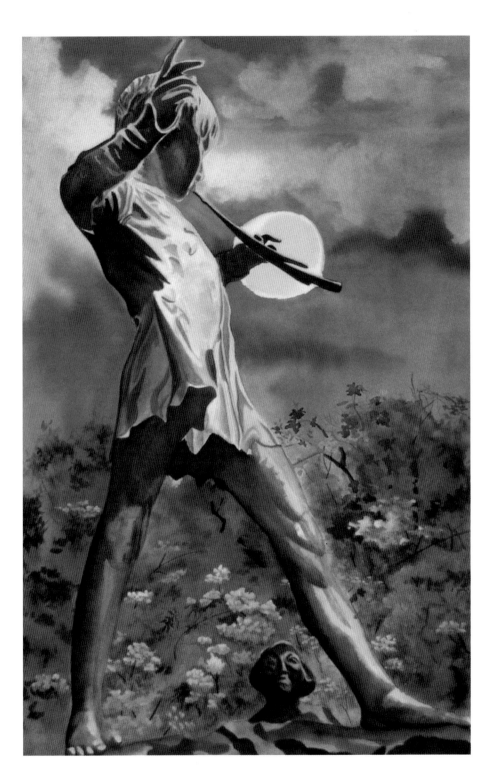

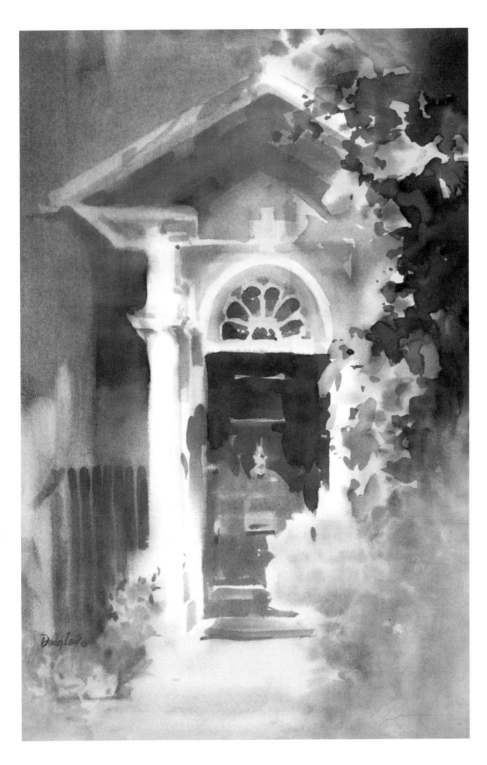

DOUG LEW
The Blue Door
13" x 20" (33 cm x 51 cm)
Arches 140 lb.

My primary intention was to make the white of the door frame and pillars be the focal point of the painting. Though the door is actually black, I felt the need to give it a muted cool color since the shadows that define the door frame were on the cool side. I decided to let one side of the painting be softer than the other to break the severe symmetry of the composition. Sharper, darker treatment of the trees to the right added depth to the doorway.

JOYCE F. PATRICK
Brilliant Passage
22" x 15" (56 cm x 38 cm)
Arches 140 lb. hot press
Watercolor with acrylic and gesso

I find abstract painting to be the
most challenging and satisfying,
with composition central to its
unique methodology. Using several
layers of glazes, I can achieve vary-
ing effects and unify one passage
with another. An opaque underpaint-
ing interspersed among the glazes
adds form to the composition while
complementary colors create impact
and cause contiguous passages to
intensify each other.

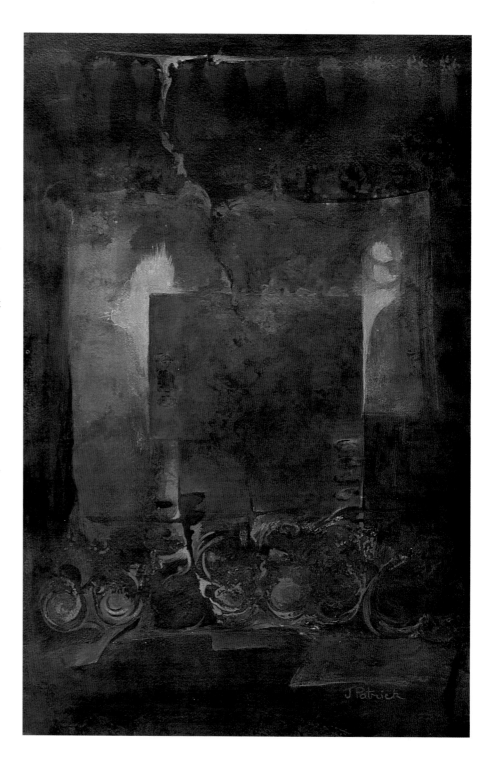

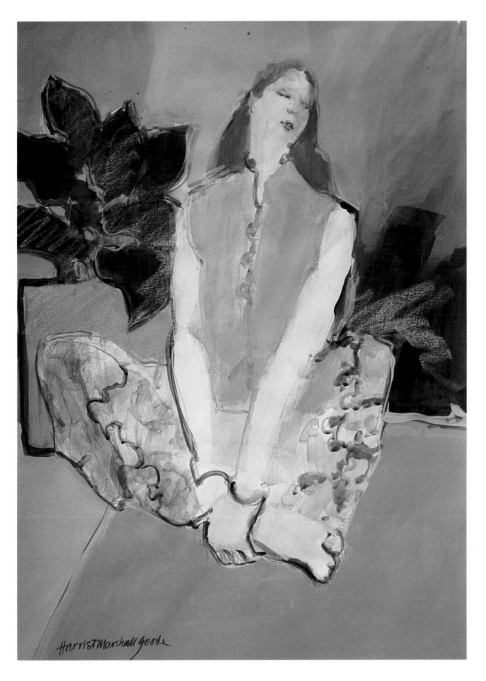

HARRIET MARSHALL GOODE
Delta with Red Hair
28" x 22" (71 cm x 56 cm)
Strathmore Aquarius II
Watercolor with acrylic

I prefer to use colors to accentuate a subject rather than dominate it. For instance, the model for this painting actually has black hair. To keep the picture plane flat, I painted across the lines of my initial drawing with color, integrating background and foreground, then re-established some shapes with the use of line.

JANE FREY
West Light
32" x 45" (81 cm x 114 cm)
Arches double elephant 555 lb.
cold press

West Light represents my appreciation of rich, full color.
Putting a wide variety of color in one painting results in
complex relationships that work as a whole; in this work,
a colorful piece of fabric dictates the selection of other
objects used. By using a strong light source, I am free to
use vibrant color in the shadows. I wet one small area at
a time, drop in local and complementary colors, and allow
them to mix on the paper. By combining rich color,
unusual combinations of subject matter, and several
different dimensions in one composition, I seek to
achieve a unique look to my work.

ALLISON CHRISTIE
Bamboo IV
21.5" x 28.5" (55 cm x 72 cm)
Arches 300 lb. cold press

This yellow bamboo, indigenous to Indonesia, undergoes subtle color changes as it ages—from the moss green and burnt sienna of its dried outer husking, to a hot Naples yellow of maturity, and a pale ash white of decay after flowering. Needing to separate the stalks, I created the midground of dark silhouettes with French ultramarine and burnt sienna and the background with greens and bright blue. After finishing the cast shadows, I needed to heighten the husks and bring them forward. These hot spots were achieved with a wash of Dr. Martin's cadmium and rose carthame.

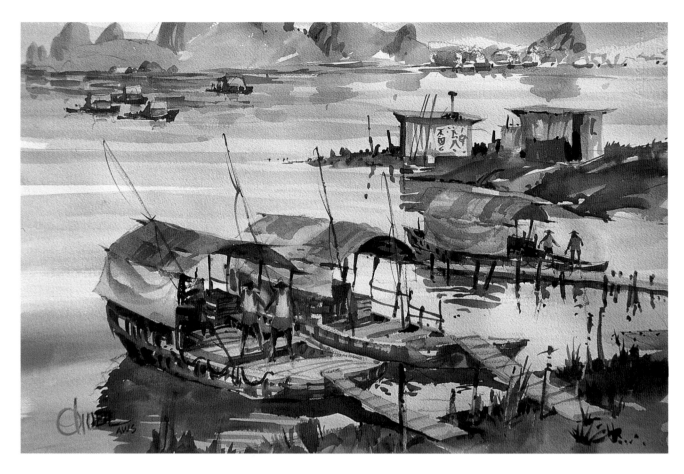

ROBERT S. OLIVER
Vietnamese Boats
14" x 20" (36 cm x 51 cm)
Arches 140 lb. rough

Color relationships and value changes are paramount in my work, with composition and other elements also being of great importance. I derive most of my subject matter from my various travels around the world. Color abounds in the landscape of Vietnam and is echoed in the people and their way of life. The boats pictured are their life and livelihood.

GERALDINE GREENE
Haitian Boat Rudder
16.5" x 25" (42 cm x 64 cm)
Arches 300 lb.

Since I am surrounded by color on the Florida Keys, my subject matter is often dictated by the intensity of color, sunlight, and shadow near my waterfront home. *Haitian Boat Rudder* was painted for its social and historical value as well as the earth colors of the hand-chiseled rudder. After masking the rudder and ropes, I tilted the painting and applied a very thin mixture of alizarin crimson and veridian with a wide brush. I continued the glazes, drying each application with a hair dryer, until the hull was defined along with the partly submerged, but still visible, portion of the rudder.

DEDE COOVER
Serendipity
26" x 26" (66 cm x 66 cm)
Arches watercolor board
Watercolor with acrylic ink

As an abstract artist, I love color and use it as a visual catalyst to create excitement, harmony, and design. I add layers of acrylic ink over the base of watercolor to create a depth of color and movement much like the brilliance of beautiful silks.

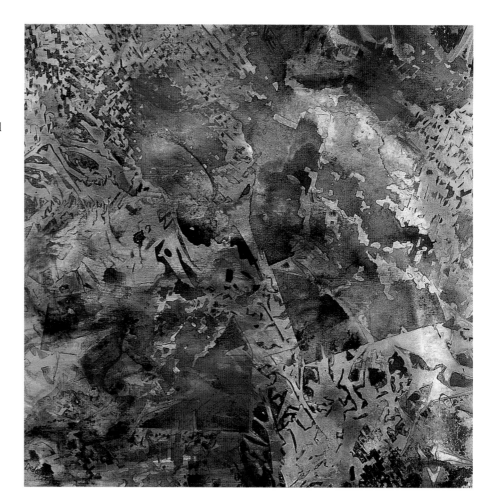

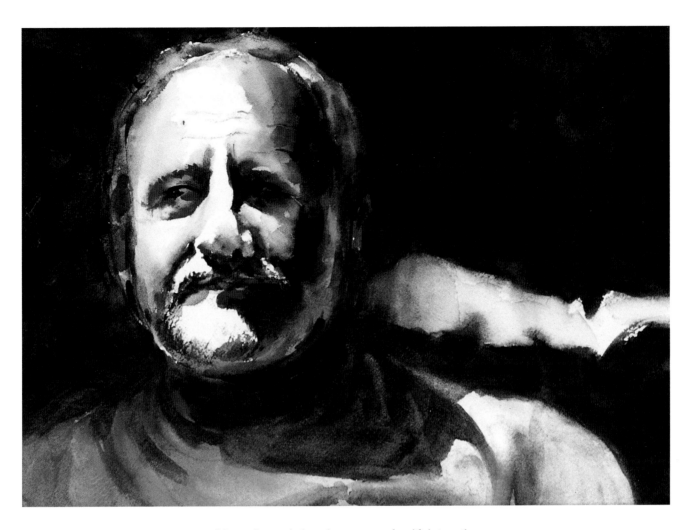

JAMES L. KOEVENIG
Orin the Wise: The Philosopher
10.5" x 14.5" (27 cm x 37 cm)
Arches 140 lb. cold press

Many of my paintings focus on people with interesting qualities. This subject is a favorite relative who was expounding on a weighty topic as the late afternoon sun streamed through a skylight. Chiaroscuro was suggested because of the strong illumination with dark shadows on the subject disappearing into the background. Traditional colors were replaced with bright transparent blues, reds, yellows, and purples painted and mixed directly on moistened paper. Details in the background were only suggested and highlights were modified to form interesting shapes and balance the work.

MARSHA GEGERSON
Irreconcilable Differences II
28" x 20" (71 cm x 51 cm)
Winsor and Newton 140 lb. cold press

I have been experimenting with the
Oriental concept of using shape and
value to create the sense of space
within a painting, either by working
with a split complementary color
scheme or a basic primary triad.
In this painting I used the three pri-
maries with an occasional bit of
violet. The challenge of this particu-
lar color choice was to be constantly
aware of which color values and
temperatures caused the spaces to
recede and which ones brought the
shapes forward. I also needed to
constantly check to see if all the
planes held together, and I found
that planning color repetitions
helped me accomplish this.

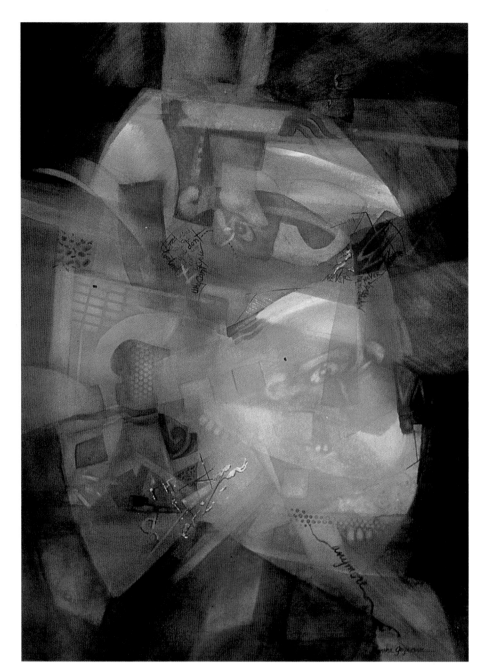

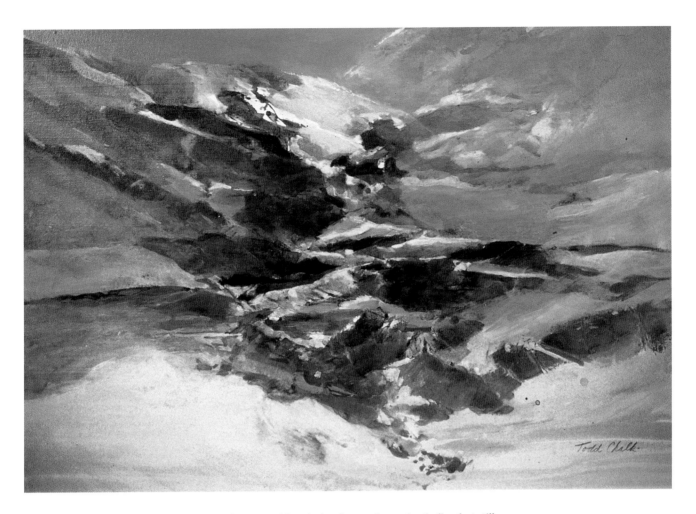

TODD CHALK
Ultimate Spaces I
30" x 36" (76 cm x 91 cm)
Strathmore Aquarius II
Watercolor with acrylic

Color gives this painting its spacious, airy feeling but still keeps its structure. Paint was laid down with paper towels and plastic wrap, stamped with paper, partly painted out then restated with white over color, working back and forth. The resulting pattern of colors play off of each other. I find this painting technique very satisfying.

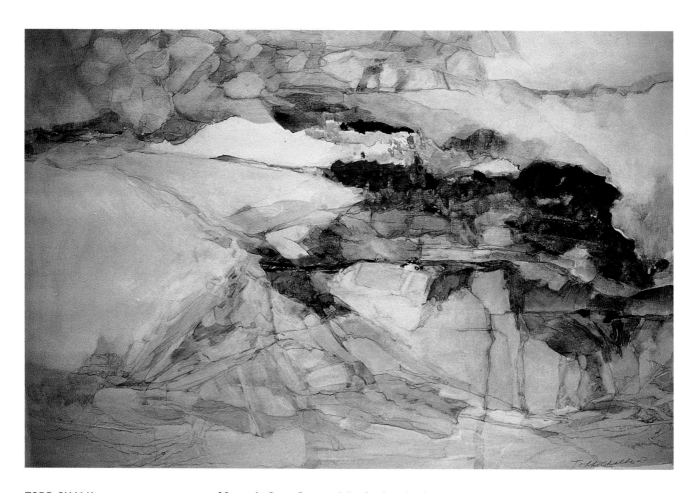

TODD CHALK
Mountain Scape I
30" x 36" (76 cm x 91 cm)
Strathmore Aquarious II
Watercolor with acrylic and pencil

Mountain Scape I uses minimal color; the drawing carries the visual emphasis of the work. Continually stating and restating patterns, I worked overlays back and forth from medium darks to lights, drawing into the image and leaving and losing shapes as the painting progressed. The dark green was included to balance the whites and give the desired fresh spring-like appearance.

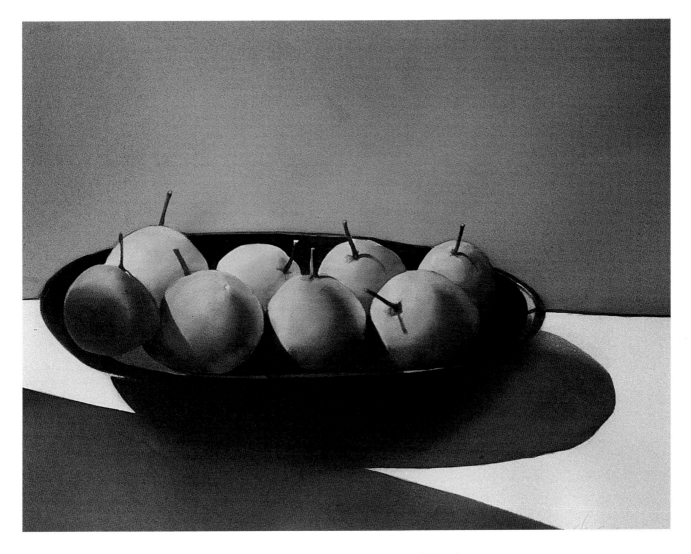

JUDITH KLAUSENSTOCK
Asian Pears
17" x 23" (43 cm x 58 cm)
Arches 140 lb. cold press

My subject matter was chosen for its familiarity, shape, and color, and was generally painted using simple formats. With transparent watercolor enabling the washing-off process, the painting was immersed in water and gently caressed to remove unwanted color, leaving a ghosted image over which many glazes were applied. Shadows helped to make *Asian Pears* unique and interesting.

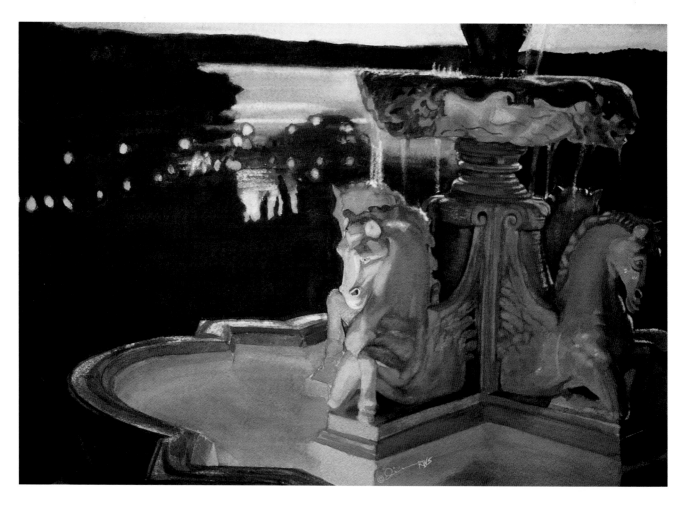

HENRY DIXON
Night Vision IV–Tablerock Lake
18" x 24.5" (46 cm x 62 cm)
Fabriano 140 lb.

Preferring Winsor and Newton watercolors with a good grade of watercolor paper, my favorite subjects are children and elderly people, old Victorian architecture, and landscapes. I usually photograph my subject matter using slides rather than prints because slides retain the subject's vivid colors. In this painting, I wanted the fountain to stand out against the blackness of the night and give it life.

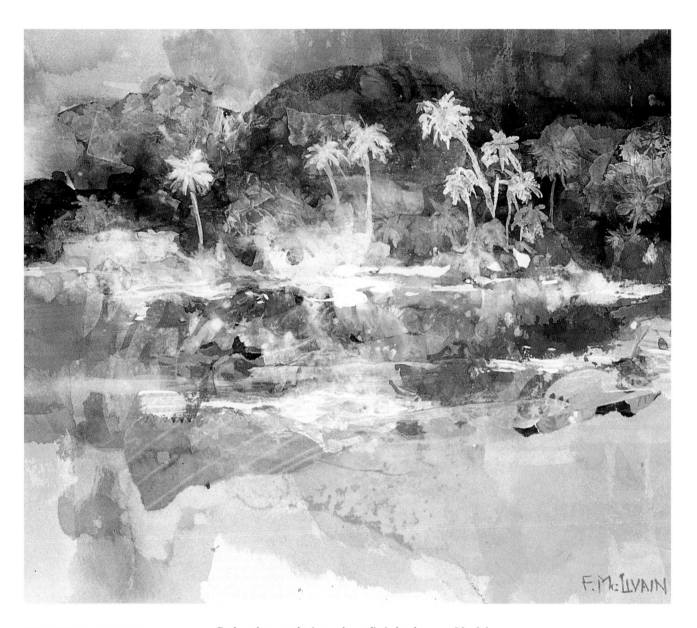

FRANCES H. McILVAIN
Tropical Island
18" x 22" (46 cm x 56 cm)
Arches 180 lb. cold press
Watercolor with gouache and collage

Rather than producing safe, realistic landscapes, I had the opportunity to try some experimental techniques in which expressing emotions and feelings became the primary challenge. New shapes and forms of foliage in Florida were the inspiration for *Tropical Island*. Pieces of a softly patterned gift bag were collaged to create the land masses. White gouache thinned to a cream-like consistency was allowed to seep through tissues, forming additional patterns and creating a feeling of mystery. Watercolor was applied to make the painting read as a landscape.

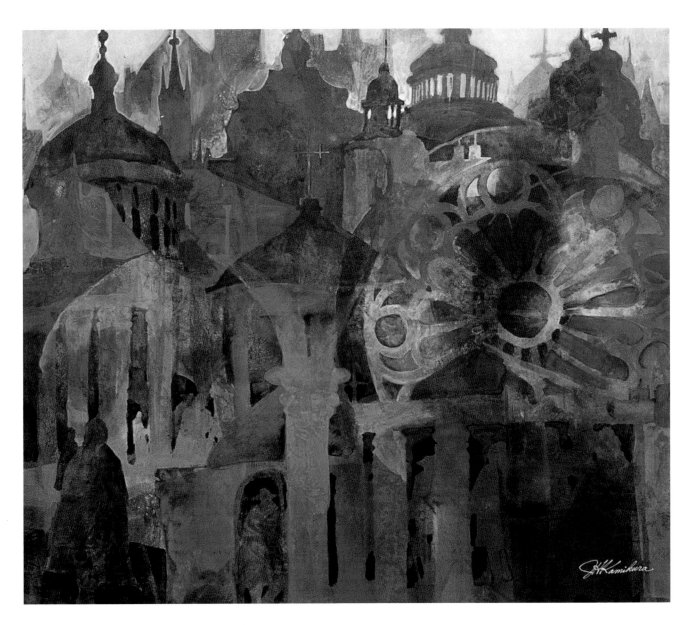

JOYCE H. KAMIKURA
Europa
22" x 30" (56 cm x 76 cm)
Lanaquarelle 140 lb. hot press
Watercolor with acrylic

Antiquity associated with old Europe was captured by painting thin layers of transparent reds and blues, layer upon layer, to convey the idea of the aging apparent in old building materials. Finishing layers in Indian red, cadmium red, burnt sienna, and raw umber gave additional warmth. While still wet, I sprayed the painting with water, rolled it with crumpled tissue, and wiped it with toilet rolls. Some sections were lifted by scrubbing with rubbing alcohol to simulate the texture of very old objects. Hot-press paper works best for encouraging the interactions of layered colors.

JANE TALLEY
Creekside
30" x 22" (76 cm x 56 cm)
Strathmore Aquarius 80 lb.
Watercolor with acrylic, ink, and collage

Providing an optical center and dynamic value, color is a major feature of *Creekside*. A limited color palette was selected to elicit an emotional response for the viewer and light and color were organized in toned blocks and balanced with line and texture. I started by applying diluted inks with a spray mister. After drying, wet-in-wet transparent watercolor was used to define the landscape. Accents of drybrushed acrylics and collage were added for texture.

ELAINE WEINER-REED
Awakening
19" x 15" (48 cm x 38 cm)
Arches 140 lb. cold press

Because my technique depended on
a wet-in-wet application of color, I
wet the entire surface of the paper
before applying subsequent washes
of new gamboge, quinacridone rose,
and ultramarine blue. Gradually, I
added the earth colors and some
opaques, leaving a dusty warmth of
colors. I continued working with
new gamboge, Holbein turquoise,
and Grumbacher yellow-green to
complete the work.

DONNE BITNER
Dance Macabre
30" x 22" (76 cm x 56 cm)
Aquarius II 90 lb. cold press
Watercolor with acrylic and watercolor
crayon

In *Dance Macabre*, I wanted to capture the drama of a performance on stage. Thin layers of acrylic were washed on and textured to create depth and dark, rich color that provided an unusual quality similar to an aged patina. There is a magical feeling to the colors on and around the stage when the dark gives way to light and spectacle.

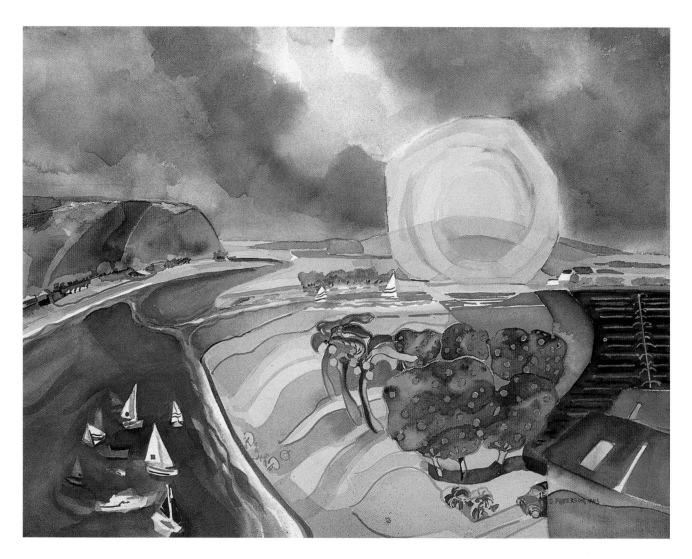

GLORIA PATERSON
The Orange Belt
22" x 30" (56 cm x 76 cm)
Arches 300 lb. cold press

Executed in a deliberately childlike style, *The Orange Belt* utilizes color choices that suggest the bright heat of Florida. The color is saturated and flat with primary and secondary colors appearing with their complements—the violet palm trees against a yellow field and blue water next to an orange field. The emphasis on simple elements continues in the circular yellow sun, and the exaggerated sun rays carry the viewer's eye around the painting. The circular composition of land carries the viewer's eye deep into space, and the sky was washed with indigo to establish a neutral element.

DAN BURT
Mexicoscape
30" x 22" (76cm x 56cm)
Arches 140lb. cold press

I use color to excite the viewers' eye, stimulate the imagination, and hold interest in the picture. Some of the pigments used in this painting were high chroma (intense), some were granulated and textural, some were subdued so they would enhance the high-chroma colors, and still others were somber tones that complemented the intense colors. I kept the shadows transparent and dark, moving them around the saved white shapes in the composition. After painting one large shadow area, I dropped other dark colors into the wet paint to add variety and spontaneity to the picture.

MICHAEL L. NICHOLSON
Piebald's Vista
14" x 17" (36 cm x 43.2 cm)
Bristol 2-ply board
Watercolor and acrylic

The coolness of the night is still evident in the saturated colors of the waning blue-purple shadows that are juxtaposed with the radiant illumination that backlights the composition. The local color of a red-earth prairie is transformed into atmospheric color of richness and depth with an organization of hue, value, and intensity. The versatility, strength, and permanence of saturated acrylics allowed me to create the initial plein air sketch and to complete the work in the studio.

WAYNE H. SKYLER
Chinatown
22" x 28" (56 cm x 71 cm)
Arches watercolor board rough

As a realist painter, color plays an important role in the creative process by setting the mood for the image. The inspiration for *Chinatown* was the wide array of brilliant colors and shapes that are unique to this part of the city, capturing an early-morning sun casting strong shadow patterns across the vibrant mix of colors and shapes. The sunlight, mingling warm colors, cool shadows, and cast geometric patterns, transforms a flat, ordinary street scene into an exciting combination of color, shadow, and texture.

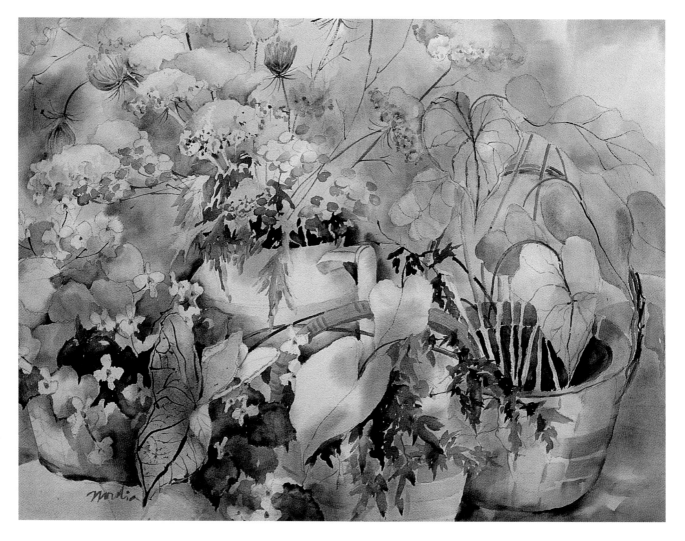

NORDIA KAY
Summer's Bounty
22" x 30" (56 cm x 76 cm)
Arches 140 lb. cold press

The color balance of *Summer's Bounty* began with initial planned color washes onto a wet surface. At this point, the painting already had color design, mood, and movement, and this set the tone of the work. Most of the strong contrasts of light and dark were kept in the foreground; I tried to show perspective through the softer, paler colors with broken details in the background.

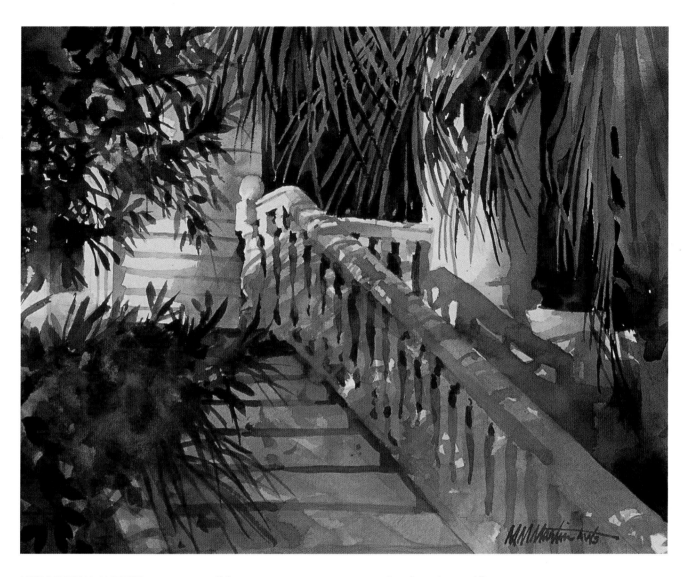

MARGARET M. MARTIN
Entree to Elegance
17.5" x 21.5" (45 cm x 55 cm)
Arches 300 lb. cold press

Color can create temperature, mood, and mystery and it is inextricably linked with value—every color has a value, and every value has a color. The vitality of color and the vibrancy of contrast were achieved by working out value relationships at the start. Warm violet shadows complement the pale yellow light areas. A limited subdued palette was used, layering thin color washes to keep a transparency and glowing color.

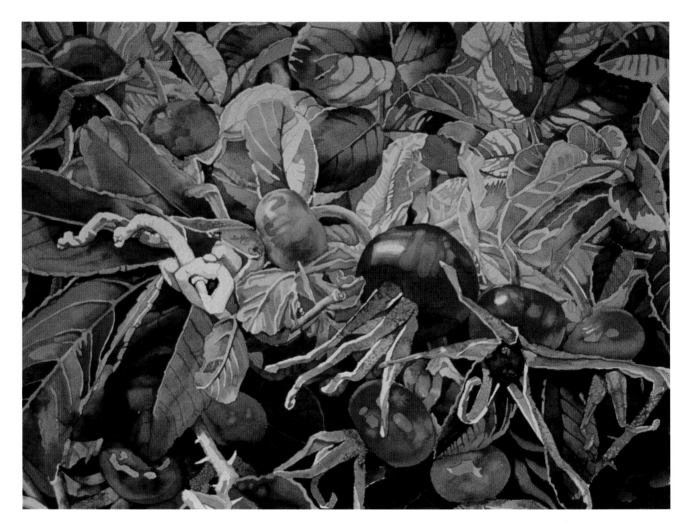

MARY SORROWS HUGHES
Coastal Rose Hips—Maine Surprise
22" x 30" (56 cm x 76 cm)
Arches 300 lb. cold press

I am stimulated by vivid dramatic color and subjects that are unusual and surprising. Watercolor is my preferred medium due to its fluid, sweeping quality and its propensity toward happy accidents and unexpected results. Salt was thrown into areas of wet paint to create texture on the rose hips, and layers of color were built up to portray the vivid green of the leaves and the red of the rose hips. Blues were later dropped into areas of the leaves. The complementary nature of the greens and reds helped heighten the visual effect of each, which added to the power of the painting's color statement.

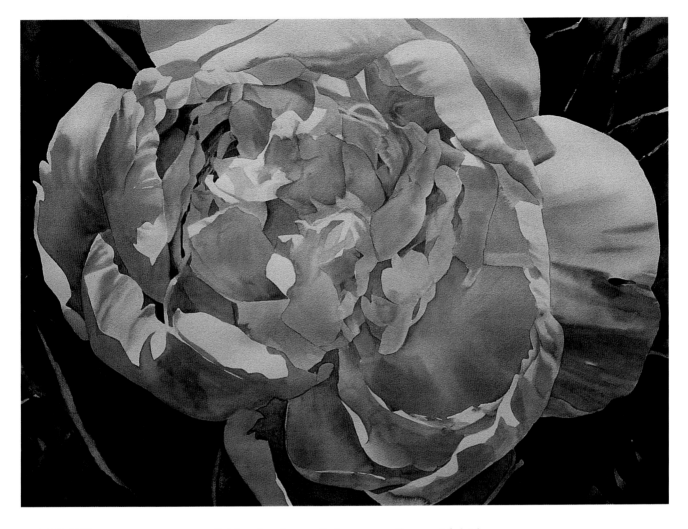

ANN PEMBER
Peony Unfurled
21" x 29" (53 cm x 74 cm)
Saunders Waterford 140 lb. cold press

Subtle color changes that occur over flower petals intrigue me. Colors can be wonderfully clean as well as lush, and are even reflected from surrounding objects. Using transparent pigments for clean, luminous results, I applied colors to wet areas and let them mingle on the paper. Complementary colors, such as the blue and orange in the petals, make the painting lively and vibrant.

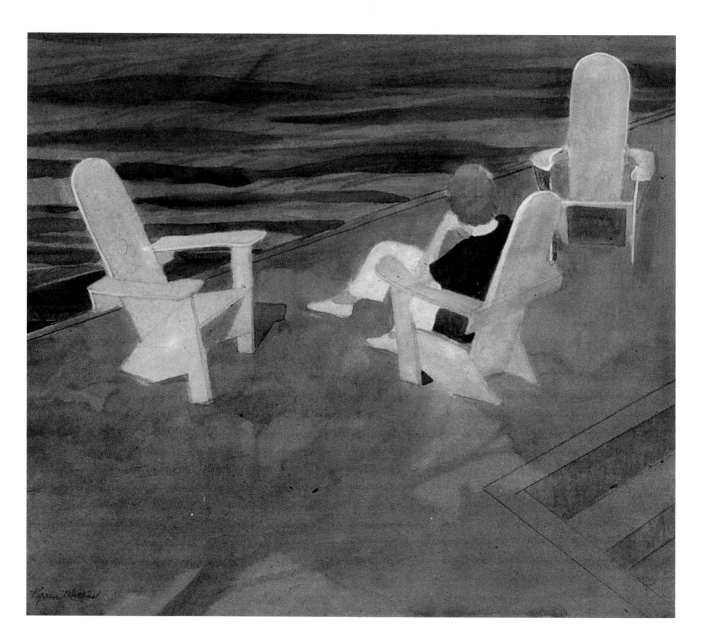

KAREN MATHIS
Vacation Stop
22" x 25" (56 cm x 64 cm)
Arches 140 lb. cold press
Watercolor with gouache

I wanted to use colors that made the subject and light around her glow. The complementary combination of crisp yellow against the more neutral violet accomplished that goal. Touches of yellow gouache were added in the violet to soften the shadows cast from the tree above and to unify the background with the yellow of the chairs. The unusual color combination might surprise viewers and draw them in for closer inspection.

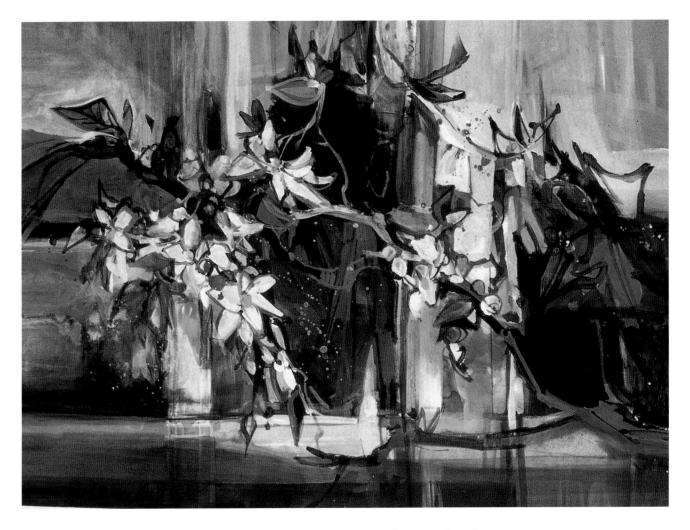

JANE R. HOFSTETTER
Emergence
21" x 29" (53 cm x 74 cm)
Strathmore 5-ply illustration board
Watercolor with acrylic

Dramatizing a tiny cluster of leaves, berries, and small white flowers presented a difficult challenge. Beginning with transparent watercolor washes of warm bright colors, I added warm and cool darks for contrast. Washes of pale acrylic in various areas gave a veiled look to the under-painting, and the subject was defined using energetic calligraphic brushstrokes. A final check made sure each piece of the subject was similar yet unique. The warm transparent color from the background gives *Emergence* much of its dramatic glow.

BENJAMIN MAU
Wind Dusk
40" x 30" (102 cm x 76 cm)
Arches 140 lb. cold press

Wind Dusk was first designed on wet paper to allow the natural flow of background watercolor to be part of the creative process. Naples yellow, burnt umber, and Prussian blue were used as the primary colors, with salt and sawdust applied for texture. Additional layers of color with touches of magenta and alizarin crimson were built up, the layering creating a rich and complex visual impact. The house and flowers were drybrushed to complete the work.

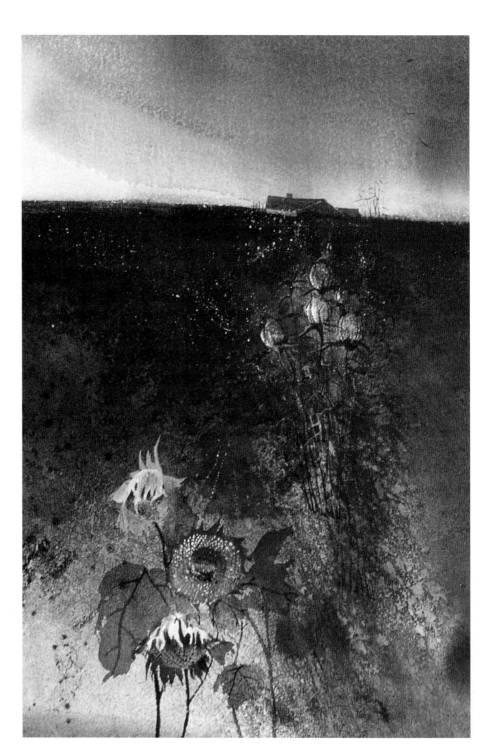

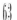

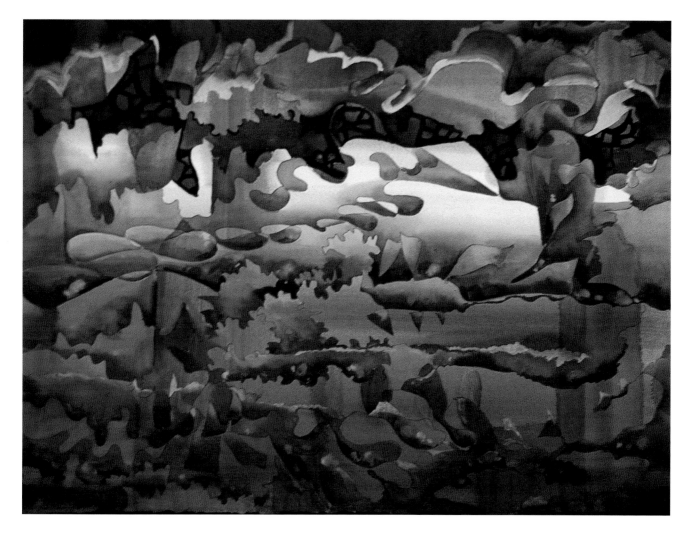

JANE E. JONES
Musical Mesa
22" x 30" (56 cm x 76 cm)
Arches 140 lb. cold press

Musical Mesa is a composition based my reaction to classical music; the music evokes different hues, color temperatures, and intensities. I began by drawing horizontal shapes when suddenly a clash of symbols created vertical shapes for conflict, which then led to a landscape. Painting wet-in-wet using gradation of hue, color temperature, value, and intensity creates visual movement. The light meets the dark yet the painting maintains a sense of unity.

KATHLEEN JARDINE
***Sacred and Profane Love: The
Copulations of Monsters***
48" x 51" (122 cm x 130 cm)
Lanaquarelle #1114 hot press

Although I work only from life, all of
my work employs intensified colors
that are used to elicit what might be
called hallucinatory realism. My
paintings are allegories that com-
press detail for layered meaning. I
have no strategy for making them;
I just work as if in a spell.

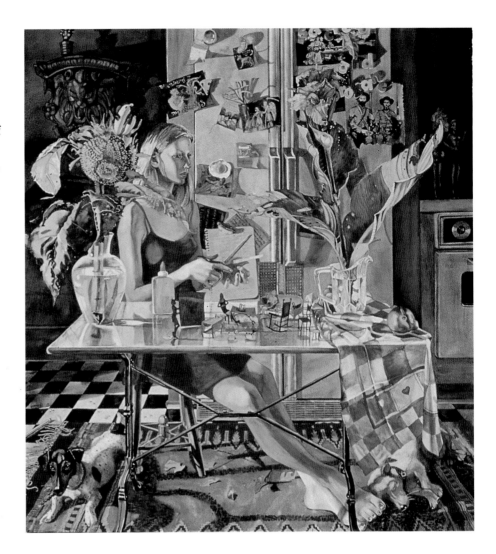

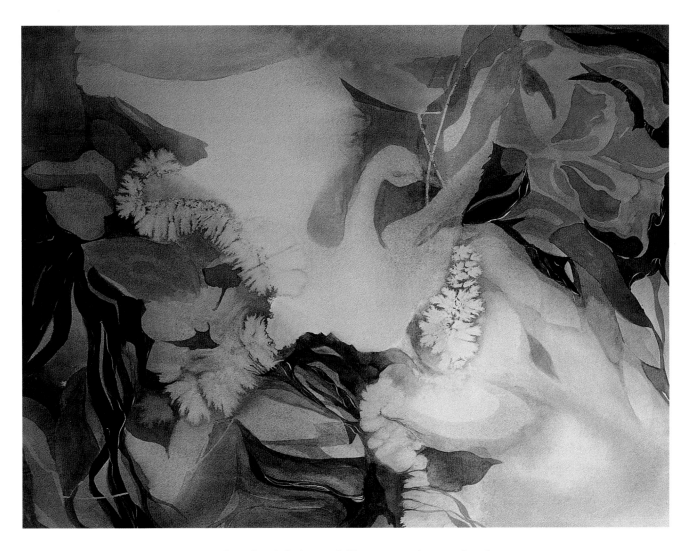

CARMEN NEWMAN BAMMERT
Water's Edge
20" x 28" (51 cm x 71 cm)
Winsor Newton 260 lb. cold press
Watercolor with white ink

I floated a triad of peacock blue, new gamboge, and a mixture of opera and rose madden on wet paper. As the colors mingled, they produced organic shapes, textures, and secondary hues. After drying, I studied the work for a sense of subject and found a wing-like shape in the saved white area and outlines of leaves and branches. I then began to develop the concept of a snow goose landing along a stream. Darks were achieved by adding thalo blue and alizarin crimson. By using a limited palette, I maintained a fresh look, and the colors gave the painting a mystical, airy feeling.

RAKA BOSE SAHA
Prelude
30" x 22" (76 cm x 56 cm)
Arches 300 lb. cold press
Watercolor with acrylic and ink

Color and composition are inter-laced and are the most important elements of my work. I do not dis-tort forms, but I enjoy unrealistic colors because they give my paint-ings an abstract quality. After apply-ing the main body of colors with acrylics, I covered the entire paint-ing with water-based black ink. When the paper was dry, I soaked it in cold water and washed it with a soft sponge. This caused the ink on top of the paint to wash away, leav-ing ink embedded in the tiny crevices of the paper. I accentuated various areas with more acrylics to complete the work.

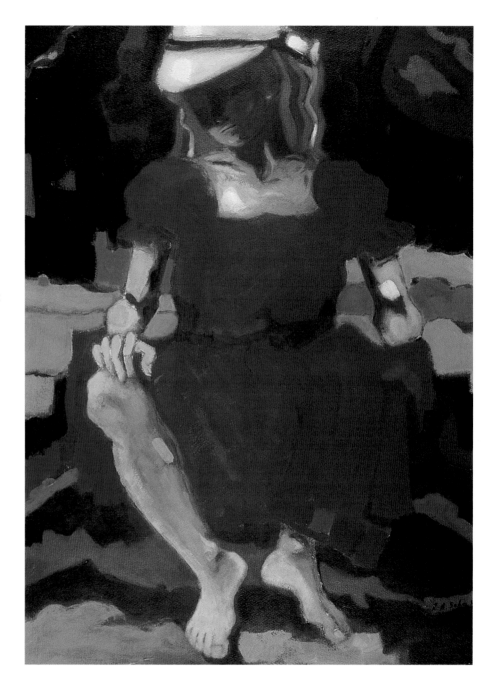

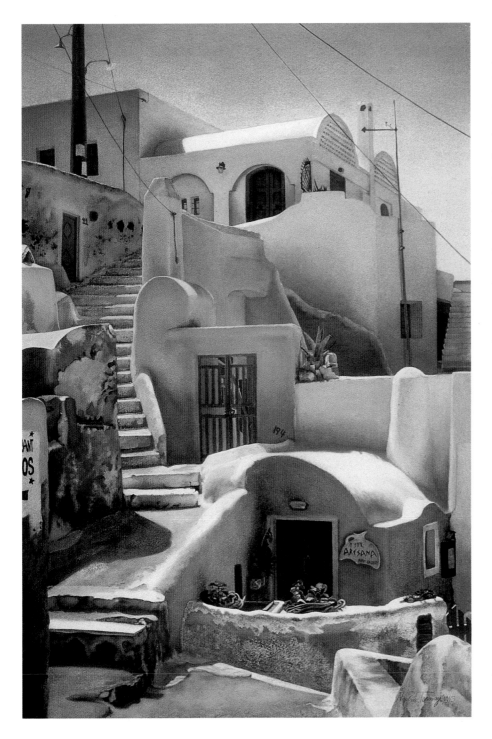

NEDRA TORNAY
Oia, Santorini
29" x 20" (74 cm x 51 cm)
Arches 300 lb. rough
Watercolor with acrylic, gouache, and gesso

When my transparent watercolor wasn't producing the desired effects, I employed other techniques to make it work. I applied gesso, then painted with transparent watercolor. White acrylic was used in thin washes to lighten values, and small sunlit plants were rendered with bright opaque gouache because complementary colors in minute areas appear dull. With transparent watercolor I juxtaposed complements to achieve brilliance, then used complementary colors as glazes to dull and darken values. Due to the intense California sunlight, the buildings could have been portrayed as being white, but I feel my colors bring more dimension and interest to a familiar subject.

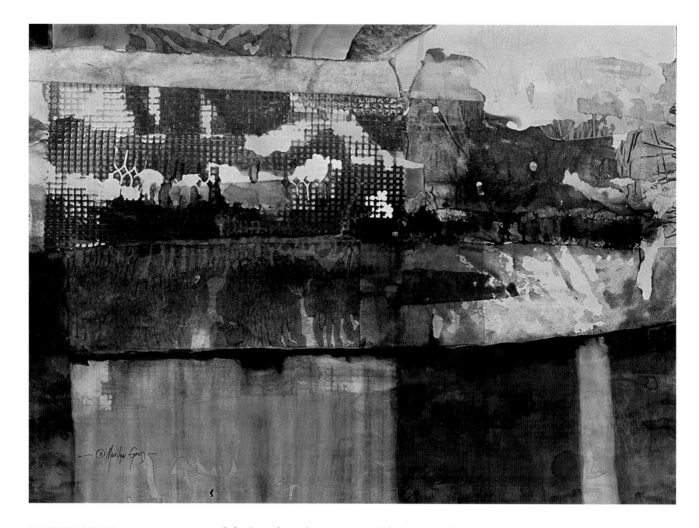

MARILYN GROSS
Urban Promise
22" x 30" (56 cm x 76 cm)
Arches 140 lb. hot press
Watercolor with acrylic, ink, gesso,
and Caran d'ache

Color is perhaps the most powerful communication tool
an artist has, since color seems to speak directly to the
soul of the viewer. In *Urban Promise*, I have used color to
convey the feeling of rural areas versus urban areas, using
large simple areas of earth tones to represent rural areas,
and more sophisticated violets and blues to indicate
approaching urban areas. Smooth open spaces represent-
ing rural areas are in quiet contrast to the more active
portion representing urban life, not only in color but also
in texture and line.

ROBERT LAMELL
Saltillo Cathedral
22" x 30" (56 cm x 76 cm)
Arches 140 lb. cold press

Late-afternoon sun casts warm rays of color mixed with spots of highlight on the front of the cathedral, reflecting up from the lit foreground. A play of warm hues, balanced by cool complements, lead into the portal with a glow of color. The light at the cathedral entrance anticipates the drama one would experience on entering the building, directing and drawing the viewer into an expected mystery. *Saltillo Cathedral* was done all at once, capturing the light as it reflected off the textured wood, setting up a contrast on the marble architectural elements.

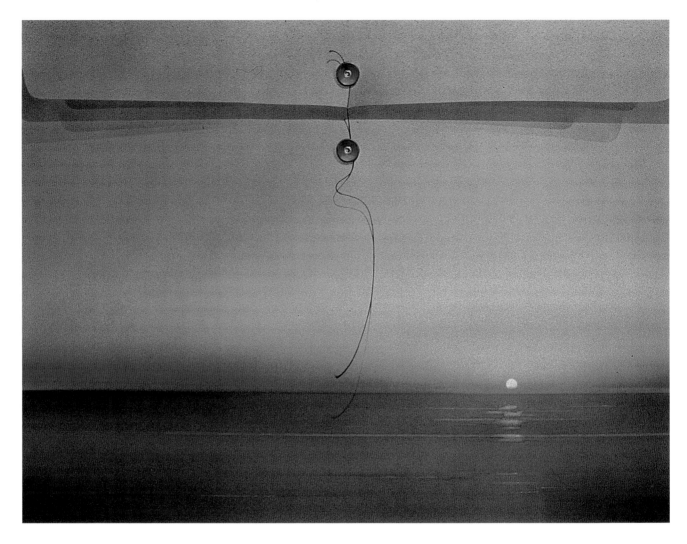

MILES G. BATT, SR.
Left-Handed Complement
17" x 23" (43 cm x 58 cm)
Arches 140 lb. hot press

The intent of *Left-Handed Complement* is to present an image that defies closure—is it a seascape or an envelope? Ocean, sky, and water are modified by changing sunlight and warm color vibrations that are produced by light on surfaces and by the atmosphere at various times of the day. Full sheet washes were applied with an Oriental Hake brush, followed by countless airbrush glazes to blend the surface with subtle color nuances. Using frisket paper for masking, the cool shadow under the envelope flap was airbrushed. Finally the buttons and string were carefully rendered with a brush.

BARBARA GEORGE CAIN
The Blues Club
22" x 30" (56 cm x 76 cm)
Arches 140 lb. cold press
Watercolor and gesso

The warm skin tones of the musicians performing at the annual art festival in Fort Worth, Texas were the inspiration for the warm colors of *The Blues Club*. For contrast, a wide range of cool hues, values, and intensities was used: blue grays, violets, darker and brighter blues to blue greens. To draw attention to the face of the larger figure, I applied the most intense color and greatest contrast. After painting the larger figures, piano, and background, I layered diluted white gesso over the background and loosely painted the other figures and musical instruments.

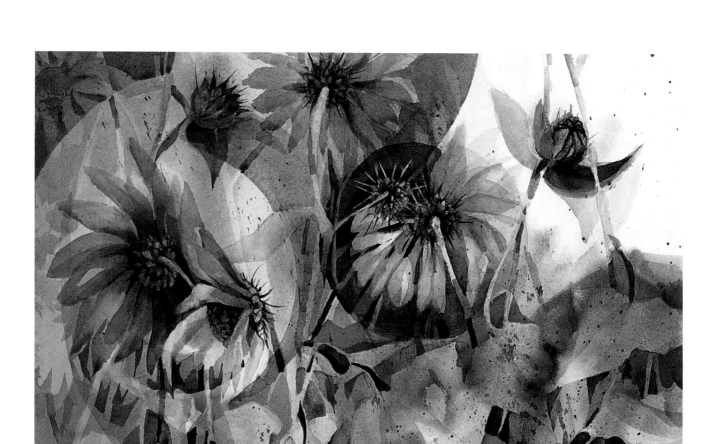

EVALYN J. DYER
Sunflower Symphony
22" x 30" (56 cm x 76 cm)
Whatman 200 lb. cold press

As part of the artistic license available to painters, my color choice is based on my emotion rather than on the actual color of the subject matter. *Sunflower Symphony* reflects my love of blues and purples. A sense of spiritual serenity is projected by the interaction of the many soft hues and darker accents which complement the analogous colors. After an initial wet-in-wet application of large areas of color to establish the dominant color theme, glazing was used to build up form with lights and darks. Brush spattering added texture and darker accents added sparkle.

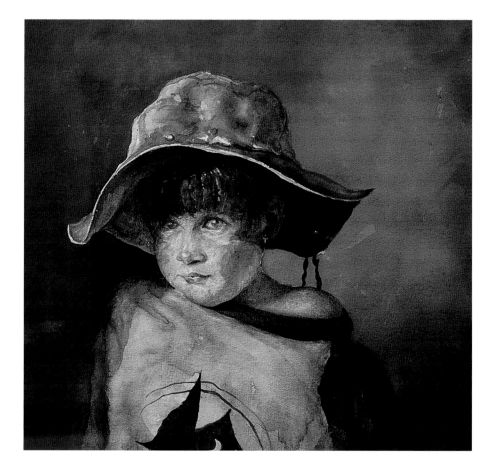

PAUL W. NIEMIEC, JR.
Black Forest
17" x 19" (43 cm x 48 cm)
Arches 140 lb. cold press

When designing my paintings, I use color relationships as a means of pursuing unity and balance. I favor a tonal approach, using grayed colors, shades, and tints, with restrained use of saturated color accents, placing emphasis upon atmospheric effects of light. For this portrait of my daughter, a dark warm background was used as a foil to focus attention on her eyes and whimsical gaze. Color harmony and richness were developed through the use of a limited palette, gradation of color values and saturation, analogous and complementary colors, and dark accents to enliven nearby colors.

RICHARD SEDDON
The Diablerets Near Sion,
Switzerland
19.5" x 19.5" (50 cm x 50 cm)
unpressed handmade paper
Watercolor with India ink and pencil

One feature of the light on a cloudy day in the Swiss Alps is the way the rectilinear forms of the ice-covered high rocks attain a pearlescent quality. The higher the gaze travels upward the more this effect is seen, until the very high slopes lose their tints and become monochrome, devoid of color. At this level, they blend into the sky until one cannot tell where mountains end and sky begins. As the gaze descends, color increases, and at the tree line, full color reigns and everything is quite distinct.

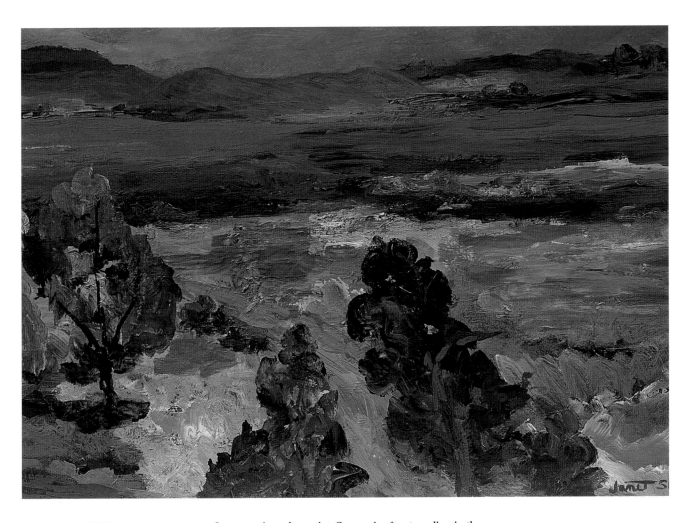

JANET SHAFFER
Crescendo
22" x 28" (56 cm x 71 cm)
Illustration board
Watercolor with acrylic

I was motivated to paint *Crescendo* after traveling in the Southwest, where I was intrigued by the colors, the open expanses, the brilliant skies, and the transcendent light on trees and land. I chose illustration board because of its stability and the way it allows a loosely rendered, somewhat abstract look. The board also tolerates additions of texture, which helped the glazes to create living color. To emphasize the push and pull of contrasting darks and lights, I applied successive layers of water-diluted color over certain areas of the trees, sky, and earth masses.

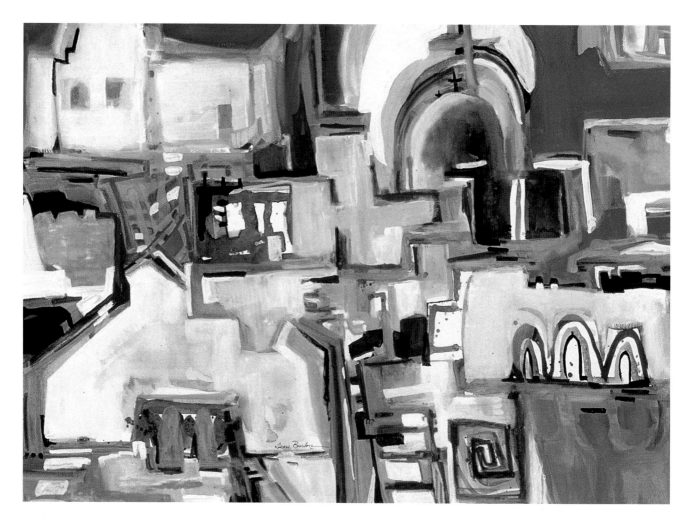

MARILYN SEARS BOURBON
Santorini I
14.5" x 21.5" (37 cm x 55 cm)
Arches 140 lb. hot press
Watercolor with gouache and
watercolor pencils

The Greek village of Santorini is perched amidst cliffs
and dramatic verticals on the edge of a volcanic bay. I flat-
tened the three-dimensional conflict of buildings and rocks
into a textured tapestry of alternating blues, whites, and
local color. On top of transparent color washes, I built
layers of gouache, which I applied, scraped out, and
sponged into lines and shapes to form positive and nega-
tive space. Watercolor pencils enhanced lines and built
color contrasts.

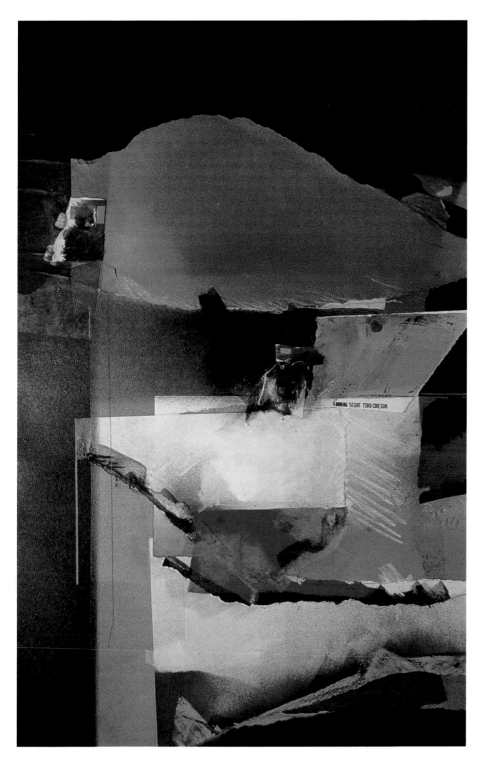

J. LURAY SCHAFFNER
A Different Freedom
30" x 20" (76 cm x 51 cm)
4-ply museum board
Watercolor with ink, gouache, pencil, and collage

Composing this painting on black museum board was a new experience for me, and I went through a process of applying a number of different papers, inks, and paints to alter the board's black surface. No matter what surface I'm working on, I keep in mind that color and value are relative concepts and depend completely on what is around them. As a composition develops, I find special satisfaction in finding a bright center of interest in most of my work as well as giving the viewer other areas to seek out and enjoy.

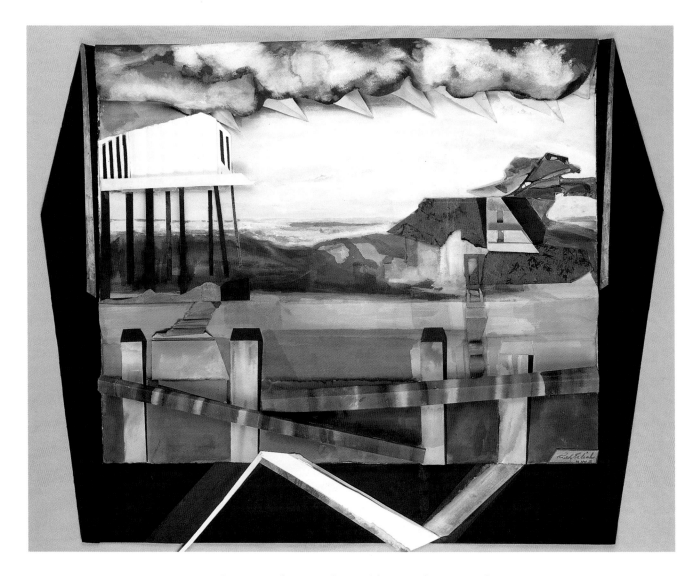

RUTH L. ERLICH
Watercolors: Third Dimensions VIII
34" x 44" (86 cm x 112 cm)
90 lb. and 140 lb. rough and smooth

I constructed separate forms with watercolor paper and adhered them to the surface of a larger sheet to establish depth and movement before beginning to paint. As I made my first stroke of color and saw the flow and clarity, my obsession with watercolor began to take hold. From then on, the colors influenced the development of the composition, with cool colors creating a hazy landscape, and bright washes of orange, yellow, and strong blue suggesting a broad, southern-California beach with the ocean beyond. Opaque white and black were helpful in establishing a pattern of light.

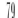

RALPH BUSH
Harbor Reflections
25" x 20" (64 cm x 51 cm)
Strathmore 500 series

A sunny day in Gloucester, Massachusetts with the fishing boats at anchor unloading their catch provided a perfect subject. The dark blue shadow of the water reflecting underneath the old wharf then out and down to the bottom of the painting added to the dynamics of the composition. The reflections in the water, the rusting red trawler, the old dock with its rotting pilings, and the scattered clouds against the deep blue sky all combined to create a strong watercolor.

HAROLD WALKUP
Reflect on the Night
21" x 29" (53 cm x 74 cm)
Arches 140 lb. rough

Reflect on the Night is the result of an experiment with color I attempted when my creativity hit a mental block. Reds in watercolor paintings are typically used as accents and rarely as the dominant color. I mixed quinacridone red, rose madden genuine, and alizarin crimson with a touch of manganese blue and covered the paper with the dark wash, adding more color around the buildings. When dry, while the shadow areas were protected with drafting tape, the light areas were lifted with a damp sponge. Darks were added for emphasis and highlights on the figure were lifted with an electric eraser.

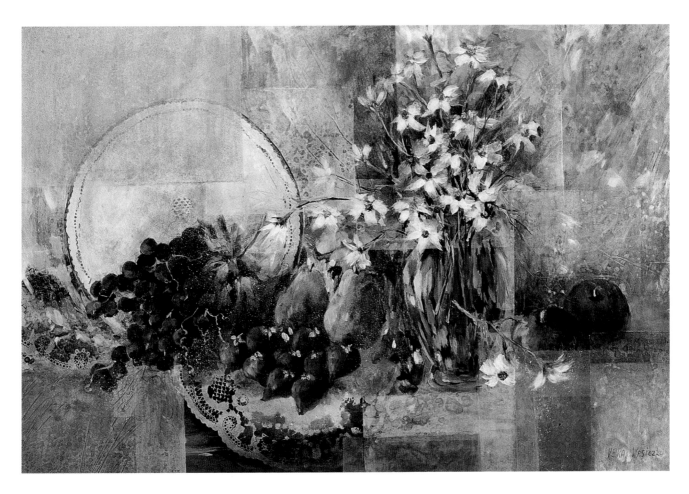

WOLODIMIRA VERA WASICZKO
A Still Moment III
20" x 30" (51 cm x 76 cm)
Crescent 100% rag hot press
Watercolor with acrylic

Working with a basic palette of alizarin crimson, cerulean blue, cadmium yellow light, olive green, violet, and turquoise, I began my painting with loose brushstrokes on wet watercolor board. I built up layers of strong color while pulling out shapes of subject matter. Using a combination of transparent and opaque glazes, I softened the darker areas and made other adjustments as the composition evolved. Cast shadows of pale color suggest a feeling of depth. Color moves subtly throughout by means of secondary box-like geometric shapes that create a backdrop for the subject matter.

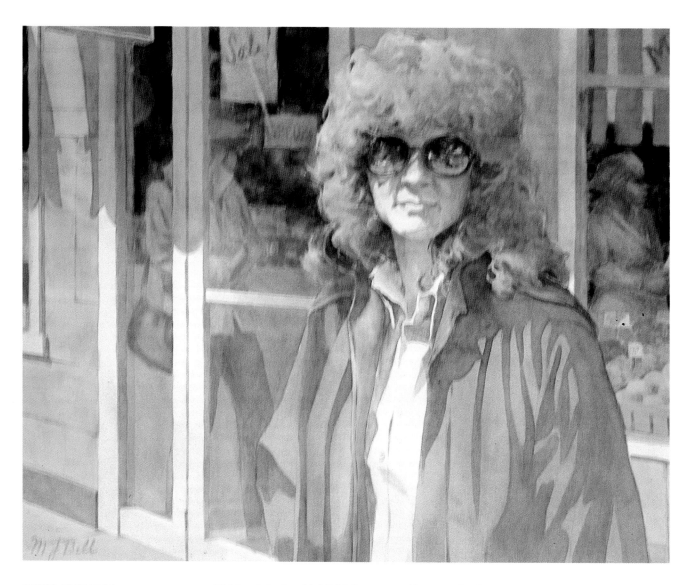

MARY JANE BELL
Jane
22" x 30" (56 cm x 76 cm)
Arches 140 lb. medium

Light and shadow highlight the center of interest, the face of the subject, which has the strongest detail. As the viewer moves away from the center, there is less detail and the light becomes weaker and the colors more muted. Background colors were kept subdued and less clear to make the background recede. Differing vibrancy of colors gives the painting excitement. I prefer to use a medium weight paper to get a cleaner painting with better contrast.

GENIE MARSHALL WILDER
Line Dance
30" x 40" (76 cm x 102 cm)
Arches 300 lb. cold press

A still life can be a living thing, its objects suggesting unlimited imagery. I brought vibrancy to *Line Dance* through the use of light, shadow, and color, obtained mainly from opposing cool with warm colors, and dull with bright colors. If all the colors were vivid, there would be no brilliance. I exaggerated these contrasts, taking the viewer beyond the actual subject matter to involve all the senses.

ELLEN NEGLEY
Fruta!
30" x 22" (76 cm x 56 cm)
140 lb. rough

In painting *Fruta!*, I used flat overlapping and offset washes of transparent watercolor to emphasize a Latin market scene—the layered buildings, leaning roofs, mass texture, and colorful groups of bustling people. The light from the white paper combined with the transparency of the overlapping shapes gives the work a chaotic dimension and energetic friction. The large, stark whites of sunlight provide contrast in a busy painting.

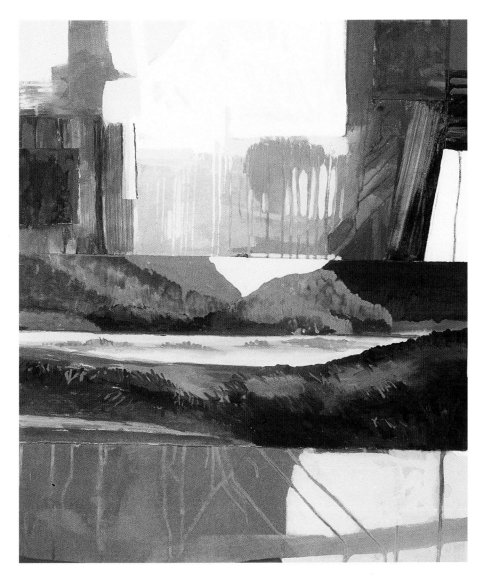

MARY BRITTEN LYNCH
Canyon Vistas
30" x 26" (76 cm x 66 cm)
Arches 140 lb. cold press,
Strathmore cold press board
Watercolor with acrylic

I found representing the compatible union of a horizontal landscape attached to a bold abstract was an interesting challenge. After dividing spaces into areas of light and shadow to provide a striking contrast, I reduced the abstract part to the simplest form making the landscape the focal point. The contrast of yellows and blues give the painting warmth and mystery, while the power of the overall design provides the viewer a subtle feeling of familiarity.

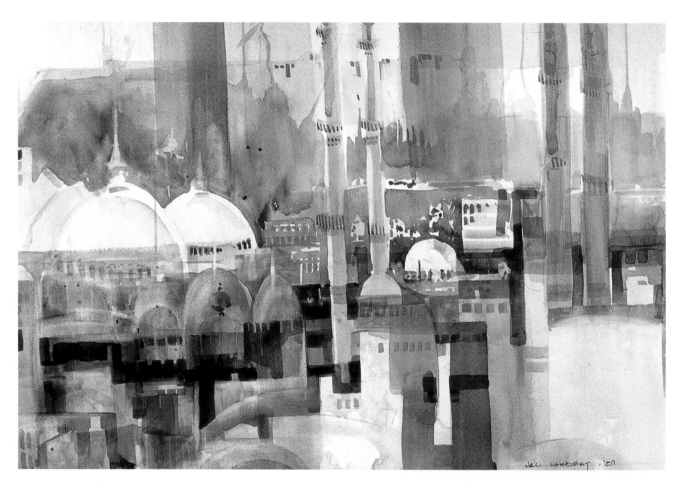

HAL LAMBERT
Istanbul
22" x 30" (56 cm x 76 cm)
Bockingford 140 lb. cold press

I started painting abstractly, pulling out both positive and
negative shapes, and using color to help describe the
architectural forms and provide perspective. Vitality was
created by the vibration of warm and cool colors and dra-
matic darks that punched out the light areas. Dark-colored
shadow accents set up an abstract rhythm that weaves
throughout the painting. Glazes of transparent watercolor
were used to create spatial distance and allowed patterns
to develop. My goal was to interpret an exotic cityscape
simply, allowing the technique to create the interest.

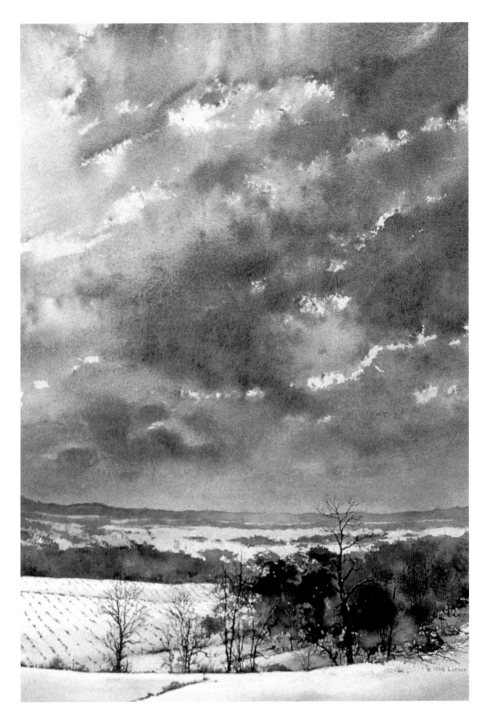

STEVEN LOTYSZ
Off 78
30" x 20" (76 cm x 71 cm)
Arches 300 lb. cold press

A landscape is a playground for sunlight, creating colors in light and shadow in ever-changing combinations. Early-morning and late-afternoon sun create the warm atmosphere I crave for my emotional, moody paintings. Often as I roam the Midwestern countryside, the late afternoon sun will emerge from behind a cloud and transform a dull, lifeless landscape into a breathtaking vista. White snow is transformed into luminescent purples and pinks; plain brown soil turns into an array of rusts and ochers; and green grassy plains seem iridescent under the long rays of the sun.

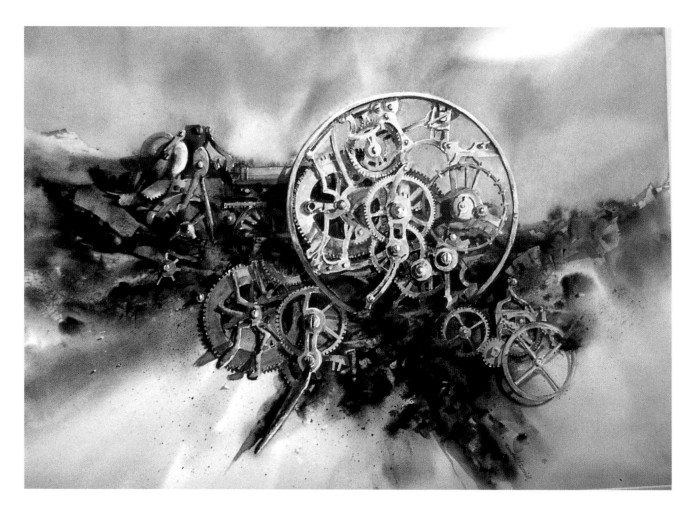

DONALD L. DODRILL
Elements of Time
19" x 29.5" (48 cm x 75 cm)
Arches 300 lb. cold press
Watercolor with Pelican Graphic White

Color becomes an important factor when the subject matter of the painting is inanimate objects; color, rather than expression, must relay the tone of the subject. Liquid masking and masking tape were used to preserve the clock gear, while washes were painted wet-in-wet to provide the soft effect of the sand. Soft muted colors in the background and foreground added emphasis to the sharper defined edges of the clock gears. Color coordination was important to the overall composition.

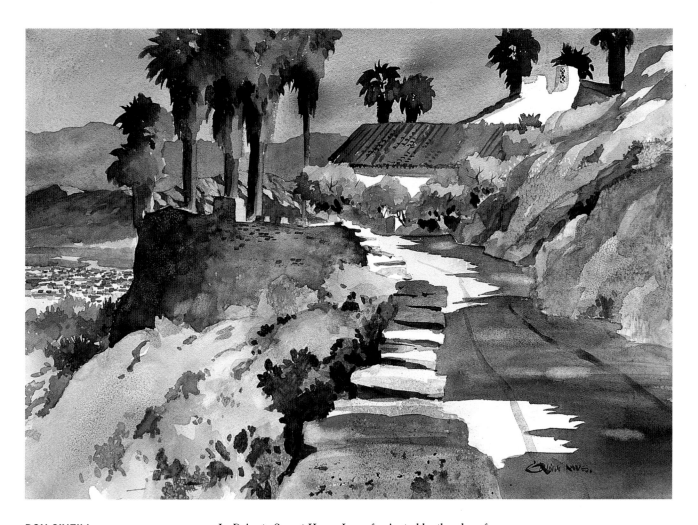

DON O'NEILL
Drive to Sunset House
20" x 28" (51 cm x 71 cm)
Bockingford 140 lb. cold press

In *Drive to Sunset House*, I was fascinated by the play of light and shadow as it flowed down the mountain, across the road, and over an old stone wall. I found this an ideal lead-in to the center of interest, the old stucco mission-style house. I achieved the bright light by painting relatively cool colors in the shadow and sky areas. Some areas required a measure of reflected warm light radiating from the nearby sunlit foliage. Rather than using neutral or grayed colors in these passages, deeper, richer colors were used to define the areas of shade.

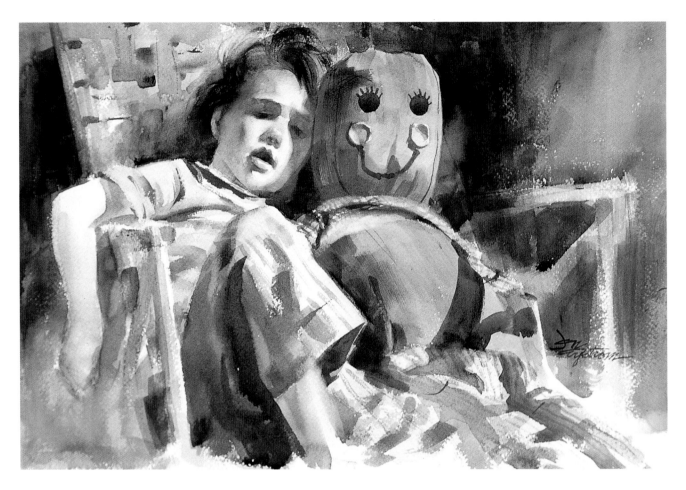

JON D. ARFSTROM
Playmates
15" x 22" (38 cm x 56 cm)
140 lb. cold press

The tranquillity of the situation portrayed in *Playmates* called for a mood supported by unobtrusive colors. The basic hues are red and its complementary green, toned back to subtler shades. For me, such a subject demanded the use of the watercolor medium with its clarity, transparent washes, and sometimes ingratiating suggestion of effortless painting performance.

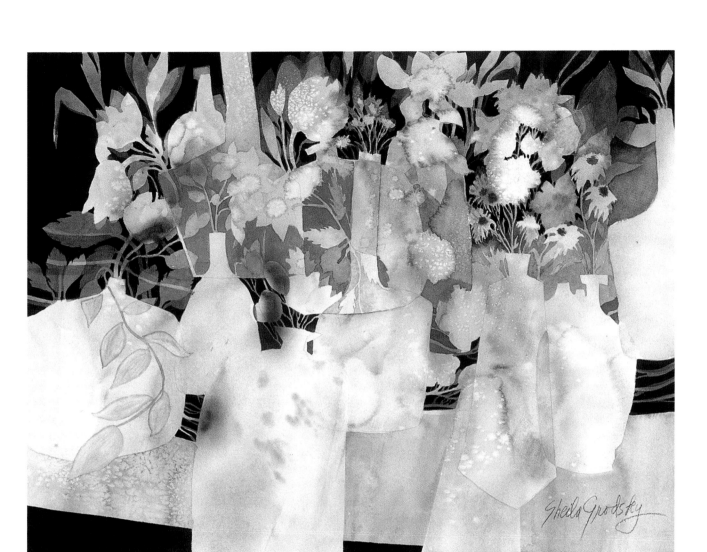

SHEILA T. GRODSKY
Bottlescape
22" x 30" (56 cm x 76 cm)
Lanaquarelle 140 lb. hot press

Attracted to rich, saturated colors, I select color for my floral paintings carefully before beginning. Once I start, I work wet-in-wet, allowing unpredictable mixtures to excite and motivate me. Colors were floated onto unstretched wet paper and allowed to flow downward on a tilted board. The paint broke up into a soft underpainting and coarse salt activated the surface. Imaginary bottles were lightly sketched in, then flowers, leaves, and stems were painted negatively. Intense darks in the background created drama and horizontal bands painted between the bottles weave the painting together.

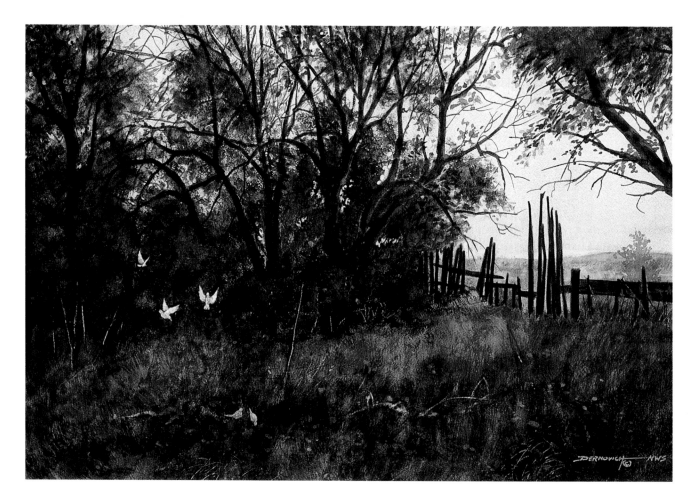

DON DERNOVICH
Doves in a Glade
14" x 22" (36 cm x 56 cm)
Arches 200 lb. cold press
Watercolor with gesso

With color as light, my attempt to capture light in *Doves in a Glade*, the time of day and a mood of tranquillity and peace was accomplished. A warm palette and strong value contrasts contributed to the emotional appeal of the painting. Heavy application of pigments on the nonabsorbent surface of the paper was conducive to creating texture and reclaiming whites by lifting paint with a thirsty brush.

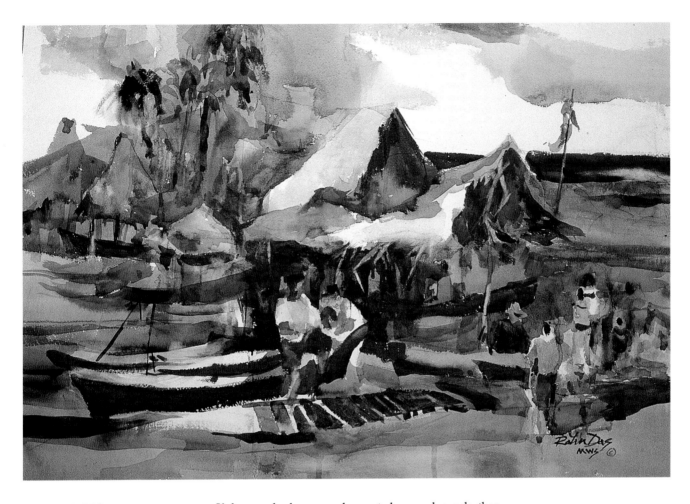

RATINDRA DAS
Mismaloya Boat Excursion Party
15" x 22" (38 cm x 56 cm)
140 lb. rough handmade Indian paper

If shape and value are analogous to bone and muscle, then color is the heart and soul of a painting. Applying colors and watching how they mix and mingle on the paper is a creative and exploratory process without limit. Colors chosen for my work are my own—intuitive, arbitrary, and with almost no reliance on local color. The heavy, irregular texture of handmade Indian paper is particularly suitable for my painting approach; I mix paint directly on dry paper to let the colors granulate and mix. This method allows the colors to retain some identity of their own, even in the exaggerated dark passages.

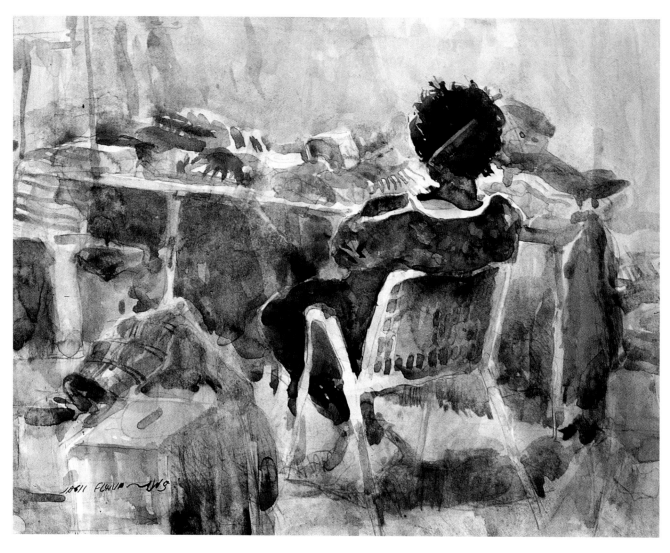

JACK FLYNN
The Red Comb
11" x 15" (28 cm x 38 cm)
Strathmore 3-ply bristol

I use only ten or eleven colors, never applying any of them directly to the paper, but mixing them on my palette and brushing on fresh pigment. I apply the paint in flat, graded washes of transparent color, placing the strongest light values against darkest ones where I want to establish the center of interest. I try to balance hard and soft edges as well as spontaneous marks and careful edges. I was attracted to the red comb in the woman's hair and made that a key element in the picture.

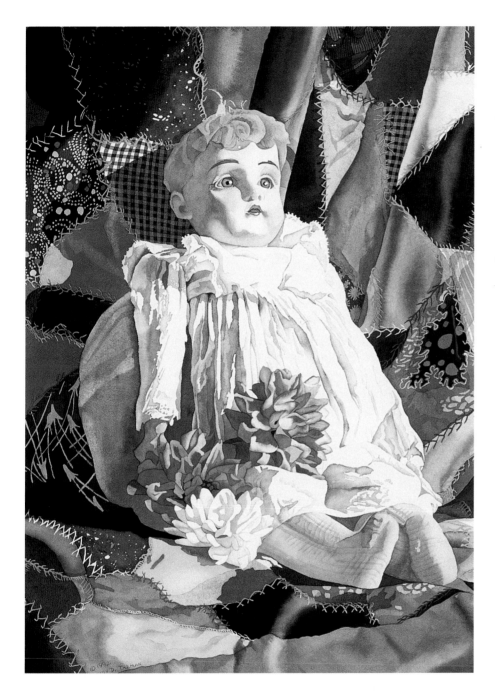

JUDY D. TREMAN
Daydreamer
29" x 21" (74 cm x 53 cm)
Arches 300 lb. rough

An antique German doll found in my grandmother's attic propped up against a multi-colored silk quilt is the subject for *Daydreamer.* Underlying purple shadows unify the painting, and a selection of relatively cool colors makes the many colors in the painting work harmoniously. The colors glow with a jewel-like clarity and brilliance because the transparent watercolors allow the white paper to shine through the paint. The rich and delicate colors of the quilt shimmer with reflected light, even in the darkest shadows.

FRANK FRANCESE
Rainy Day—Varsi, Italy
15" x 11" (38 cm x 28 cm)
Saunders Waterford 140 lb. rough

I used color to indicate the faint out-
lines of the imposing buildings and
narrow streets of Varsi on a rainy
day. Without pencil guidelines, I
applied pure color on a dry surface.
While the paint was still wet, I intro-
duced more color and let it mix on
the paper to achieve the wet, granu-
lar effect of a rainy day. Pure cad-
mium colors were applied over the
dark grays to complete the painting,
directing the viewer's eye toward
the focal point, which is the impos-
ing arched passageway and the
faint outlines of people and their
umbrellas.

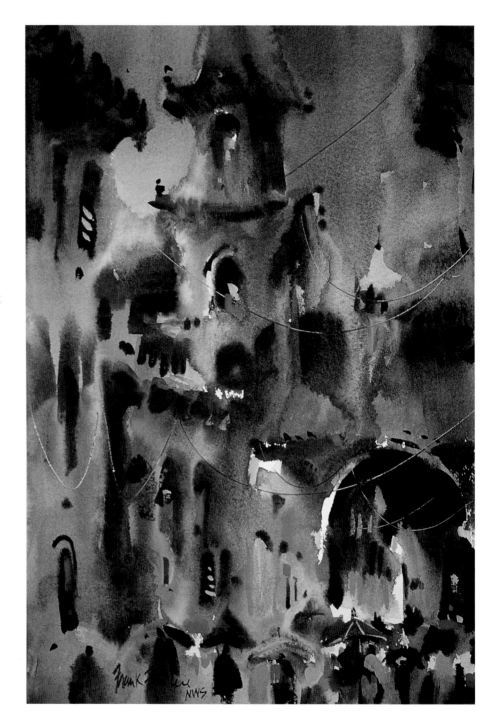

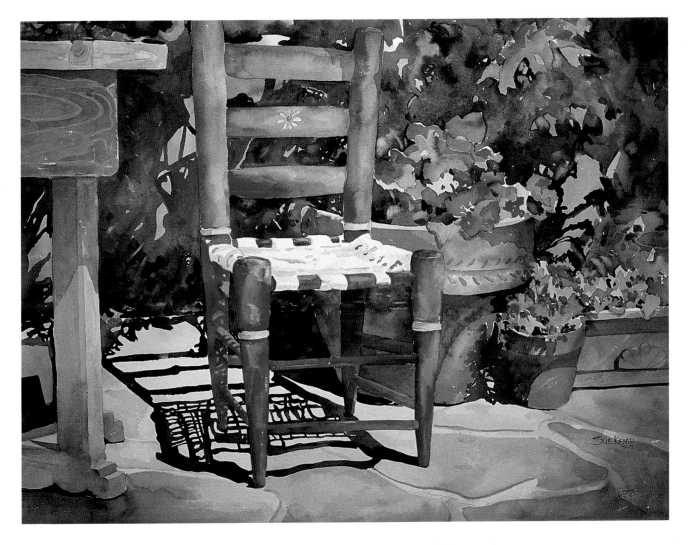

SUE KEMP
The Red Chair
22" x 30" (56 cm x 76 cm)
Arches 300 lb. cold press

As I explored Taos, New Mexico, a bright-red chair, standing alone, casting wonderful shadows on a stone walk, caught my eye. After moving furniture and clay pots in the process of design, I captured the moment with my camera. In my studio, I quickly applied vivid colors one next to another and allowed them to mingle and explode into exciting dark patterns that set the stage for *The Red Chair*. Glazes of red were applied over some of the greens and vice versa, creating harmony in the complementary color scheme.

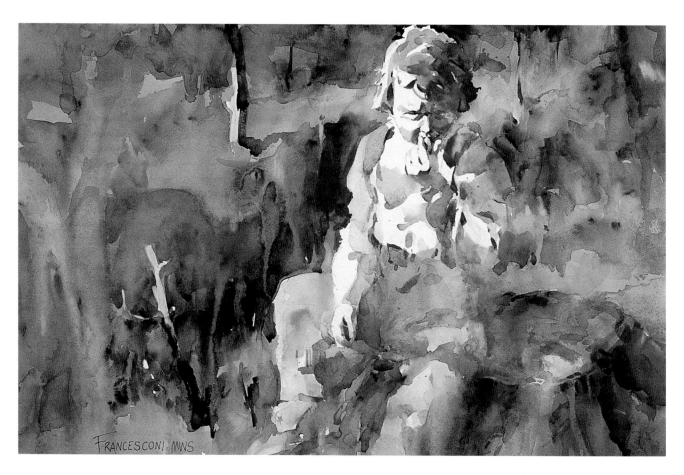

TOM FRANCESCONI
Snack Time
13.5" x 20.5" (34 cm x 52 cm)
Winsor and Newton 140 lb. cold press

Since the birth of my first son, I have discovered countless opportunities to explore color. *Snack Time* reflects one such effort in which I chose yellows and oranges to convey a sunlit feeling. By allowing the paint to run, I explored textural possibilities while suggesting dappled light. Dramatic complements around the upper portion of the figure elevated the visual impact of my subject. In concert with the other elements in this painting, color declares a presence of warmth and contentment.

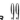

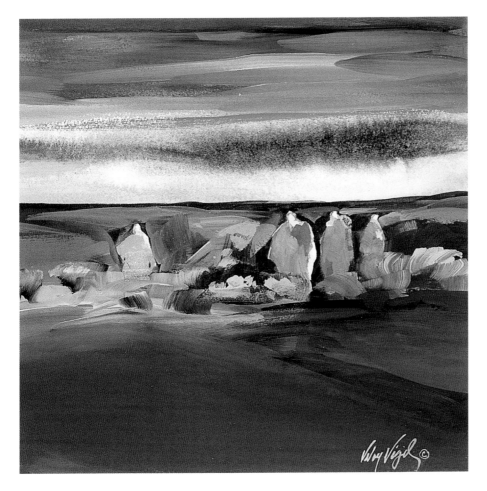

VELOY J. VIGIL
Chamisa and Asters
11.5" x 11.5" (29 cm x 29 cm)
AHC 3-ply board
Watercolor with acrylic and gouache

The figures in *Chamisa and Asters* were placed in front of an area of neutral grays; the great shadowy background contrasts with the colors in the foreground. The landscape and the sky were created with the use of contrasting values and quick brushstrokes. All of this adds to the feeling of concealment within the flora.

SUSAN LUZIER
Madeline Magic
15" x 22" (38 cm x 56 cm)
Arches 140 lb. cold press

Of all the elements and principles, my relationship with color is the most fickle. My only constant in the use of color is the desire for the deepest, richest, and sometimes most velvety, effect I can accomplish. I use mostly the pigments that will afford me that wonderful granulated appearance. With careful layering of color, the painting takes on an old-world patina reminiscent of ancient times.

LOIS SHOWALTER
By the Window
21" x 14" (53 cm x 36 cm)
Fabriano 140 lb. cold press
Watercolor with acrylic, gouache,
nu-pastels, and ink

Color choices directly effect the patterns, shapes, and the strong light and dark values I enjoy in my work. Color, whether harsh and bold or timid and muted, pushes and pulls shapes forward or away. I began by staining the paper with ink and acrylic washes of complementary colors. Lighter layers of watercolor and gouache were applied, allowing transparent colors to sparkle through. The subject became less important as the shapes of color and design developed. Complementary colors created the pattern of light and dark.

LEATRICE JOY RICHARDSON
Discordant Duet
29" x 21.5" (74 cm x 55 cm)
Lanaquarelle 300 lb. cold press

Glazing with color in its purest form creates an atmosphere through which all color is diffused. Intensity of color allows me to create emphasis and visual excitement. There is an excitement that surrounds the warm browns and tan of his violin and skin tones, the orange and blue color in his hair, the pattern of greens, blues, and yellows in his pinstriped suit, and the purples of his trousers. This offers stark contrast to the other figure who, by using a restricted palette, recedes behind him, though she is the active figure.

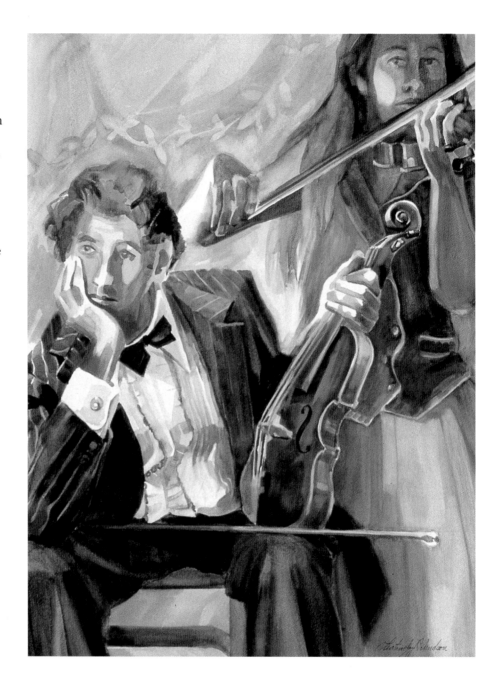

GWEN FOX
Taos Autumn
20" x 30" (56 cm x 76 cm)
cold press board
Watercolor with acrylic

As the core of my work, color empowers me to share my inner vision of creativity. In *Taos Autumn*, the viewer is seductively drawn into the painting with flat patterns of exaggerated color. By taking color several steps beyond the norm, the painting is filled with excitement and anticipation. Shadowed mountains give a monumental feeling and empower the bright colors.

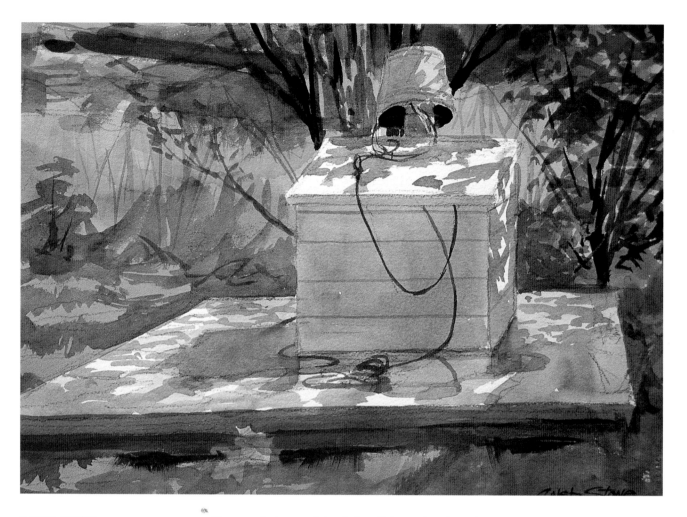

CALEB STONE
Island Well
11" x 15" (28 cm x 38 cm)
Arches 140 lb. cold press

The cast shadows and dappled sunlight coming through the small trees created an interesting pattern in the intimate scene. I try to be honest with my color and limit my palette to warm and cool yellows, reds, and blues. I mix my own greens and violets and use no blacks, instead mixing complements to achieve warm and cool darks. I left the white of the paper to capture the warmth of the sunlight and used a blue-violet mixture to establish the shadows. That combination creates the feeling of light within the painting.

DEAN TEAGUE
Blue Lagoon
22" x 30" (56 cm x 76 cm)
Arches 140 lb. cold press
Watercolor with gouache

The play of light and shadow make a constantly changing palette of color in our world. Transparent watercolor over white paper gives luminous and glowing color. I started *Blue Lagoon* by pouring red, yellow, and blue over wet paper and covering it with a plastic trash bag, moving my hands over the surface, then leaving it to dry. I removed the bag and painted the abstract shape with shadow and found wildlife and flora. Gouache was used to define some of the shapes. The red of the flower adds drama, and the deep blue of the negative space suggests mystery.

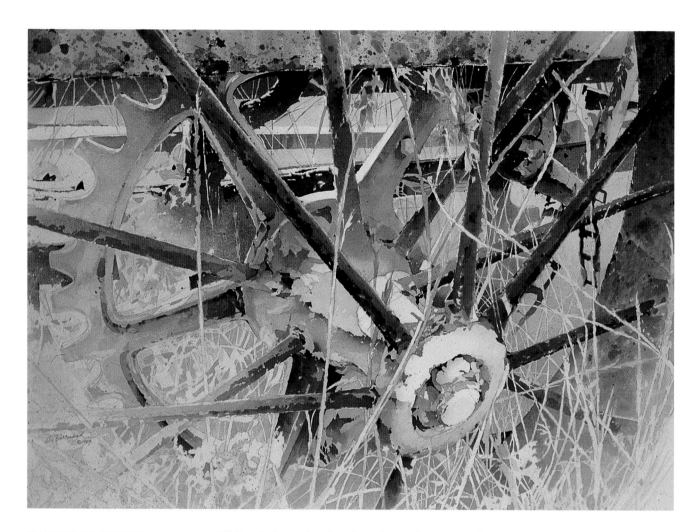

CHARLES F. BARNARD
September Splendor
21.5" x 28.5" (55 cm x 72 cm)
Arches 300 lb. cold press
Watercolor with acrylic

While painting on location along the northern coast of California, I came upon a crusty, pitted piece of ranch equipment half-buried in back-lit dry grass. Because the subject was in near silhouette, I heavily overexposed several reference slides, probing the shadows to provide information for a studio painting. The transparencies were full of detail unnoticed at the site, and their pale, cool, and distorted colors inspired me. As I painted, I shifted toward warm hues, overstating the reflected light, and developing an image quite different from the original find, but one that captures the feel of this late-summer scene.

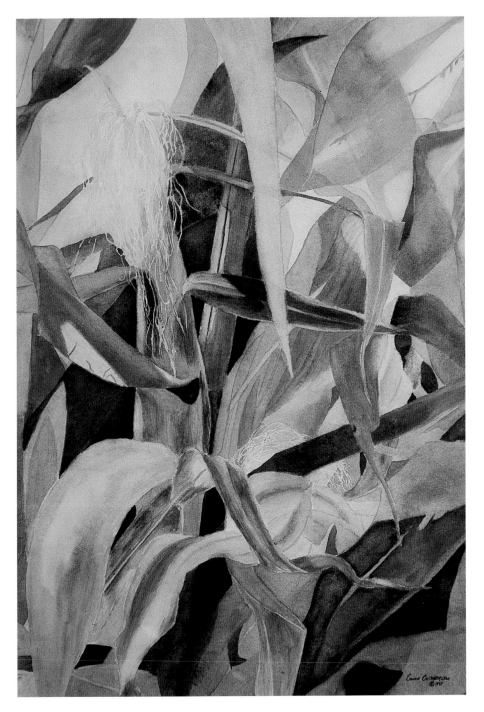

CONNIE CUTHBERTSON
Strands of Silk
30" x 22" (76 cm x 56 cm)
Arches 300 lb. hot press

In *Strands of Silk*, the colors were carefully chosen to set the mood. I was concerned that the intense yellows and greens present in the bright sunlight would be overpowering, so I toned them down with subtle glazes. By adding red as a complement, I was able to control the movement within the painting. I began with a light sketch directly on the paper then wet the entire surface and began pouring and brushing on the light and middle values. When dry, the darkest value was applied and touches of warm and cool greens and reds added interest, unifying the painting and allowing it to glow.

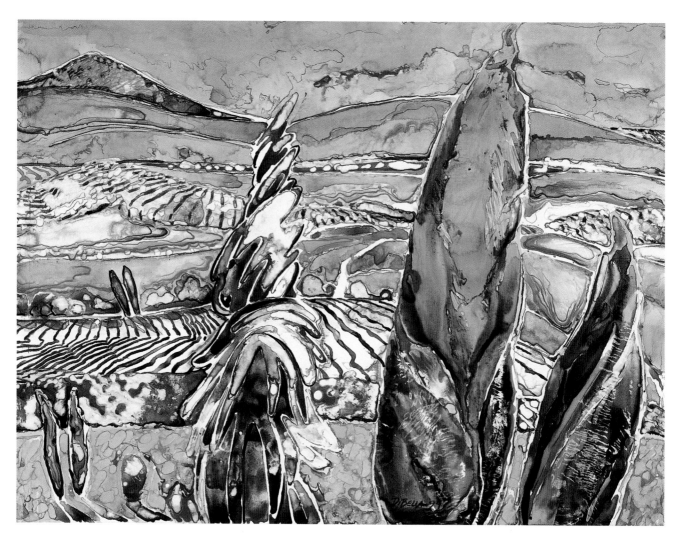

JOSEPH C. DiBELLA
Paesaggio Italiano VIII—Toscano
22.5" x 30" (57 cm x 76 cm)
Arches 140 lb. hot press

The importance of color in this work is drawn from subject and technique. Near the town of Pienza in Tuscany, I saw the incomparable clarity of Italian sunlight coaxing colors to assume an orchestrated richness and harmony. Monotype technique, a transfer of the dry image to moistened paper, furnished the means of dividing and combining hues that I further modified with additional opaque and transparent washes. The heat of the Italian sun against the cool luxuriance of the foliage was just the chromatic contrast I sought and was able to achieve with this process.

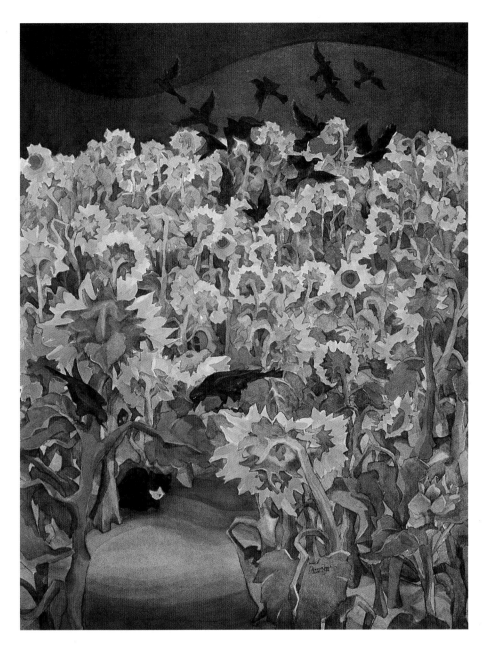

JANET WALSH
If You Snooze—You Lose
30" x 40" (76 cm x 102 cm)
Lanaquarelle 555 lb. cold press
Watercolor with aquacryl

The inspiration for this painting began with the title, *If You Snooze — You Lose*. Rather than paint a bright sunlit field, I made the scene dramatic by capturing the feeling of a late, moody day. Particular attention was paid to the selection of the colors of the backdrop: green, grayed oranges, purple, and turquoise. Several layers of transparent watercolor were applied, and aquacryl was applied over the watercolor to create depth of value and enrich the colors. The colors enhance the rhythm and unity in the painting.

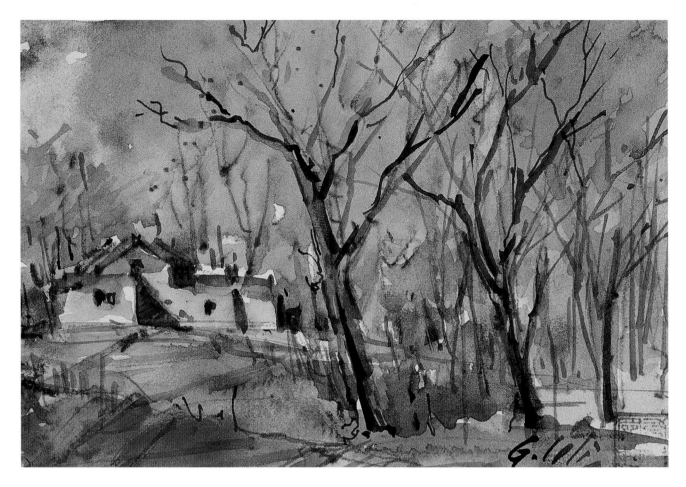

GEORGE S. LOLI
Yellow Trees
8" x 10" (20 cm x 25 cm)
Arches 140 lb. cold press

The sun is such an integral part of the vast Louisiana landscape that it leaves its mark regardless of the season. On a pleasant autumn day, I found a unique collection of trees to paint. Working on site, the entire sheet of paper was first covered with faint yellow hues that initially brought the subject into being. With subsequent layers of value, the trees became further defined until I spontaneously arrived at a compositional balance of light and shadow. I brought the emotion into the studio, where I took the liberty to exaggerate the atmosphere with brilliant color.

LESLIE R. BARBER
Reflections of Cambridge
28" x 20.75" (71 cm x 53 cm)
Arches 300 lb. cold press

In *Reflections of Cambridge*, I was drawn not only to the wide range of value within the image but also to the wide range of colors displayed. Different color temperatures created by the surrounding light and objects contrasted cool colors of the buildings with warm reflections in the windowpanes. Two windows on opposite sides of the building created a unique imagery. The foreground window panes not only reflect the sky and buildings before it, but allow one to see through to the opposite window and beyond. The translucent nature of watercolor suggests the conveyance of light.

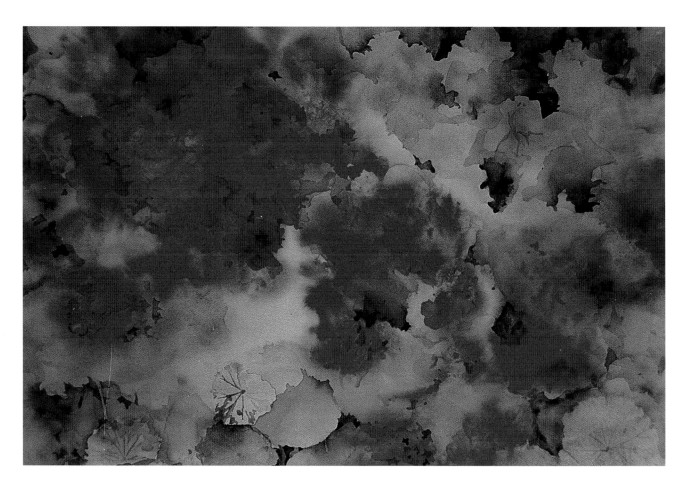

DIANE J. O'BRIEN
Blythe's View
22" x 30" (56 cm x 76 cm)
Winsor and Newton 260 lb.

Working wet-in-wet, I first applied layers of strong, vibrant, warm colors and then glazed with cool colors to create shadows and depth. While the paper was still damp, I pressed live geranium petals and leaves into the painting to give texture to the underpainting. When dry, I glazed several layers of rich color to develop value changes that weave the viewer through the work. I finished with negative painting and darker glazing of shadows. The rich color of the blossoms and leaves gives the feel of real geraniums.

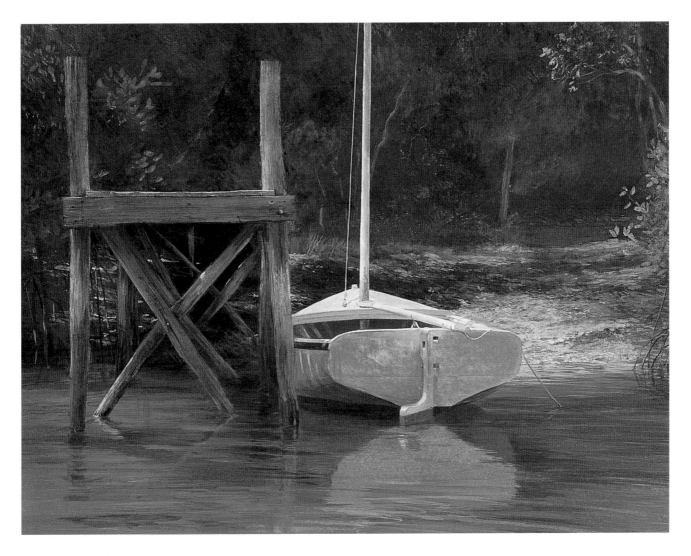

JERRY ROSE
Creekside
17" x 22" (43 cm x 56 cm)
gessoed illustration board
Watercolor with egg tempera

The warmth of the highlights in *Creekside* create the illusion of sunlight and light filtering through the trees. Though there is very little intense color throughout the painting, the careful manipulation of grays helps build a foil against which colors can react. Egg tempera allows for more precise control over the glazing process. Multiple glazing layers allow for an endless variety of neutral tones that set off the few areas of pure color within the painting.

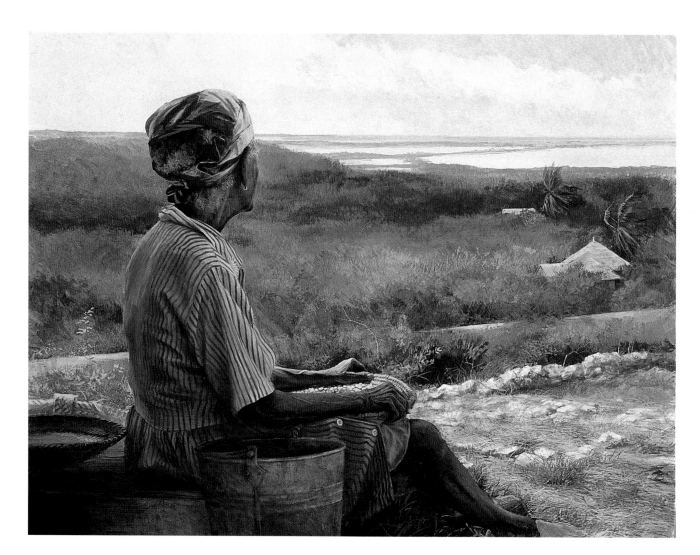

JERRY ROSE
Joe's Sound
18" x 24" (46 cm x 61 cm)
gessoed board
Watercolor with egg tempera

I prefer to use color in a subtle way. The interplay between the temperature of color—warm against cool, cool against warm—is important as a means of delineating form. By using egg tempera, I gain more control over the glazing process. Tempera allows colors to dry quickly so the slightest changes in temperature can be observed. In *Joe's Sound*, the viewer should feel the figure is in shade because of the cool colors used in the foreground while the rest of the painting is bathed in the warm tones of a hot summer's day.

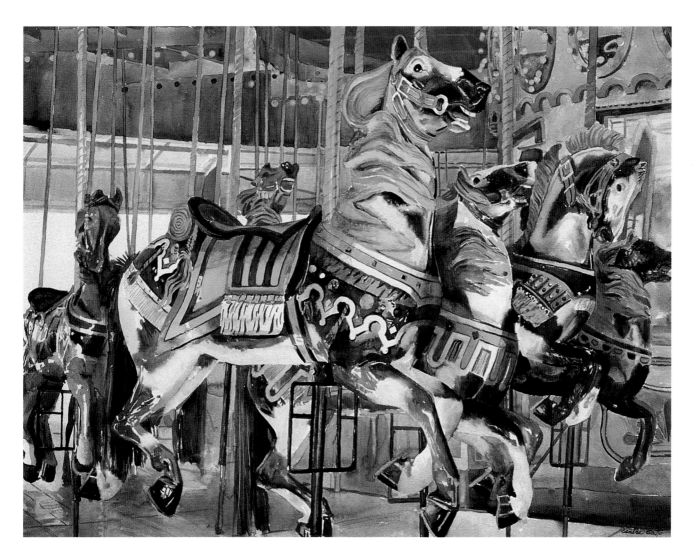

SANDRA SAITTO
Jumping Pintos
22" x 30" (56 cm x 76 cm)
Arches 140 lb. cold press
Watercolor with gouache

By defining form, color creates a sense of depth and depicts the illusion of movement. It is this effect that makes the dazzling carousel horses in *Jumping Pintos* even more exciting. The foreground horse was painted in warmer, brighter colors to capture the eye of the viewer and bring back a kaleidoscope of childhood memories.

ANGELIS JACKOWSKI
Cañafistolo Llanero
49" x 49" (125 cm x 125 cm)
140 lb. hot press

In *Cañafistolo Llanero*, color generates energy and interest by juxtaposing bright and dark color gradations. Expressive colors and provocative settings attendant to tropical flora call for thick, rich, bold colors. I apply colors so they are opaque in order to create the richness my compositions require. Heavy papers with a slight texture give my colors an added touch of dimensionality. These color contrasts illustrate the tension between the incandescent flora and the dark foliage and shadows. This creates both a sense of brooding mystery and revelation, with color used as a metaphor for life's triumph over death.

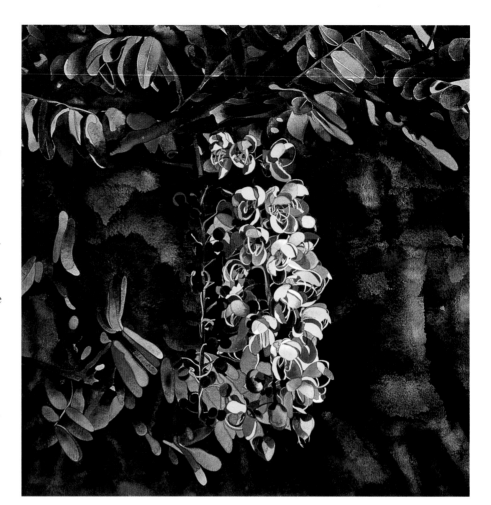

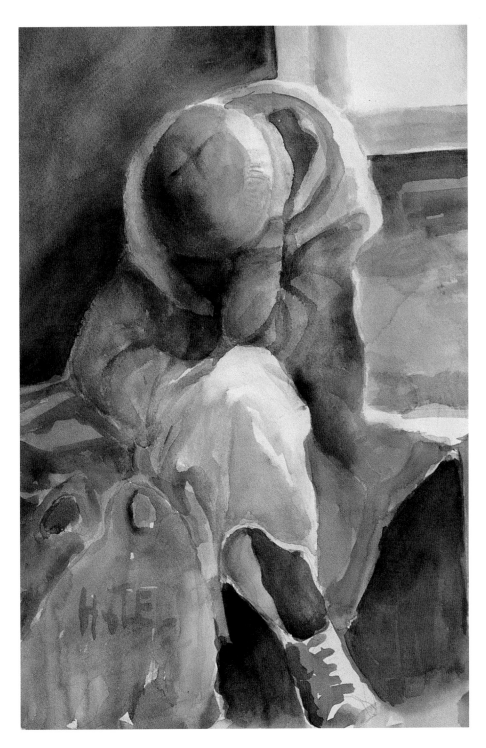

MILLIE GIFT
Depths of Despair
30" x 22" (76 cm x 56 cm)
Fabriano 140 lb. cold press

In *Depths of Despair* I wanted to portray someone who could be any of us, whose gesture communicates a sense of isolation. I chose warm and cool grays to capture the essence of homelessness, and a grayed green to convey pervasive gloom and despair. Sallow light from the window offers the only glimmer of hope. I use a loose, direct, spontaneous painting technique, with some glazing, to achieve a larger-than-life quality, leaving the white of the paper for the lightest areas. The soft pink-beige of the dress and the pure viridian of the hat contrast and complement the deeper somber gray colors.

DOROTHY D. GREENE
Ficus Payapa II
29.5" x 22" (75 cm x 56 cm)
Arches 300 lb. rough

Color was a demanding element of *Ficus Payapa II*. The intense sunlight striking the trunk of this enormous tree is contrasted by the cool blue and purple shadows cast by limbs, leaves, and nearby foliage. I exaggerated the warm yellow-orange reflected color within areas of shadow to further contrast with the cool blues and purples. The green vines and foliage growing down the trunk and at the base of the tree are complemented by the warmth of intertwining roots growing around the trunk of the tree. I limit my palette to warm and cool primary and secondary transparent colors.

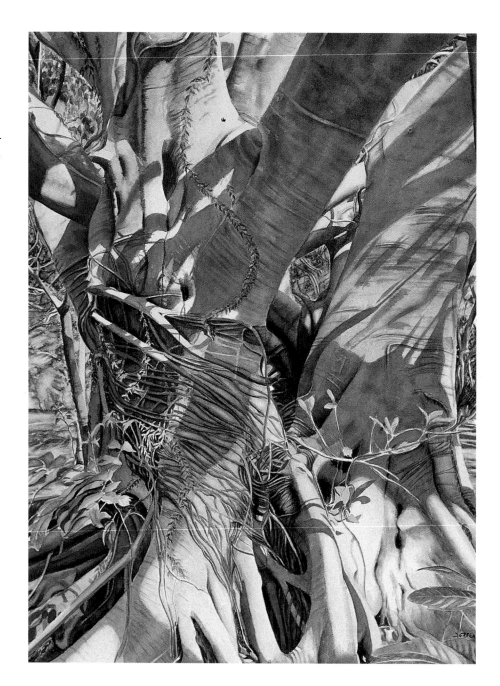

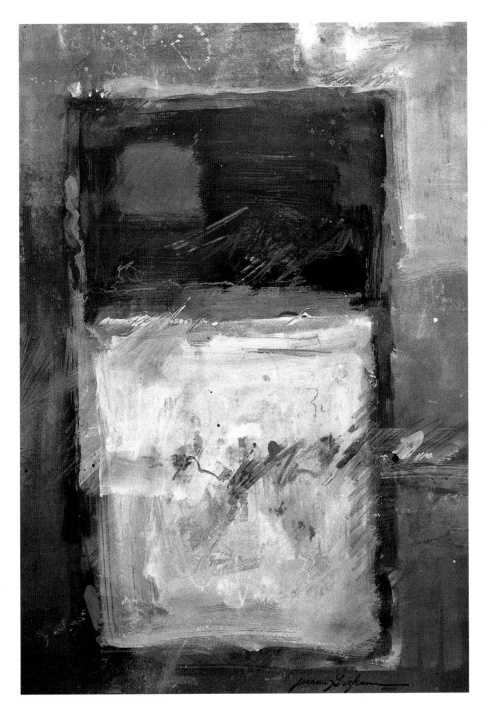

JEANNIE GRISHAM
Blueberries Over Rainier
21" x 14" (53 cm x 36 cm)
Lanaquarelle 140 lb. hot press
Watercolor with gouache and crayon

The human journey through life is filled with layers of dark and light, sorrow and joy, woven in contrasting levels of color. An individual who struggles and then breaks free from society's structure may soar to greater heights of originality. These color layers make up the supportive element of my painting. Various hues, used as building blocks for depth, created the appearance of texture vibrations in the work. By deleting all subject matter, I was able to concentrate on the play of hue and value. I use any and all materials to scratch, wipe out, and add anything to achieve this play of varying hues.

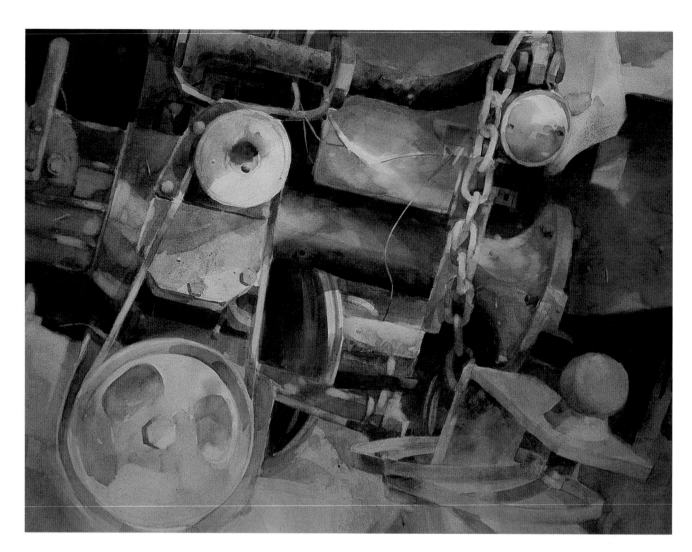

EDWARD MINCHIN
One RPM Too Many
29" x 36" (74 cm x 91cm)
Arches 140 lb. cold press

Generally focusing on close-ups to present the ordinary in a more interesting way, I selected this subject for its intriguing flow and interplay of abstract shapes and lines. There is a similarity of shapes, lines, and directional flow in both mechanical and organic subjects. After preparing a number of thumbnail sketches, I chose the one with the strongest design and composition. I laid down large washes of transparent watercolor in primary colors and let these colors establish the warm and cool areas through to the finished painting, enabling me to maintain pure, fresh colors throughout.

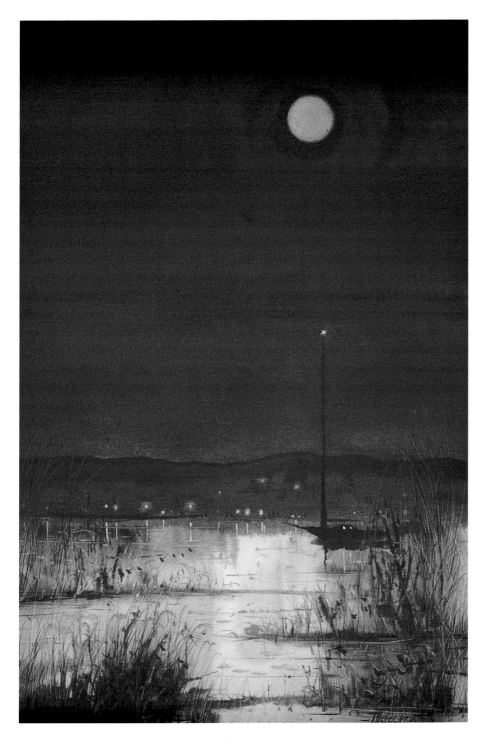

FRED MESSERSMITH
Harbour Lights II
22" x 30" (56 cm x 76 cm)
Arches 300 lb. cold press

Since my summer studio overlooks
Edgartown Harbor at Martha's
Vineyard, the subject of lights
reflected on water is a recurrent
theme in my work. At times, my
color selection happens before the
subject is clearly defined. The sheer
joy of applying a brush loaded with
vibrant color onto a sheet of 300 lb.
Arches is reward enough for fifty
years of searching for gold at the
end of the rainbow.

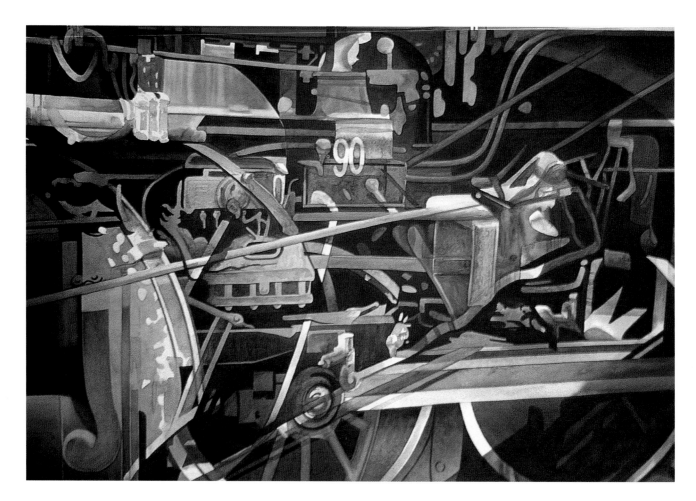

RICH ERNSTING
In a Different Light
18" x 28" (48 cm x 71 cm)
Crescent 115 hot press

In a Different Light is a train montage with changing patterns of overlapping shapes and colors. I have always found the old train shapes intriguing, especially when they are overlapped. Adding warm colors to the normally cool tones of the old locomotives makes the viewer take notice and really establishes the visual effect of the painting.

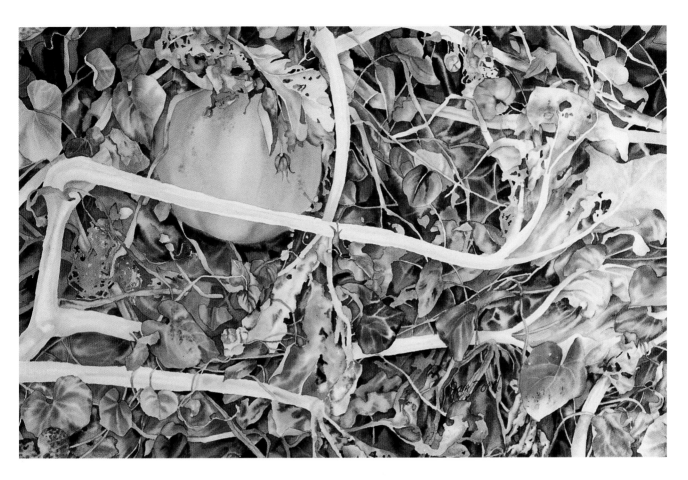

JANET J. FORD
Nature's Tapestry
22" x 30" (56 cm x 76 cm)
Arches 300 lb. cold press

Color is the driving force throughout my creative process, and I am acutely aware of how the complements interact with one another. For instance, when mixing a bright orange, I never use a cool yellow because the green in a cool yellow neutralizes the orange tone and reduces its intensity. This is true whether mixing colors on the palette or layering them on the painting surface. My goal is to achieve beautiful tones that entertain the viewers by constant and subtle changes in the movement of color.

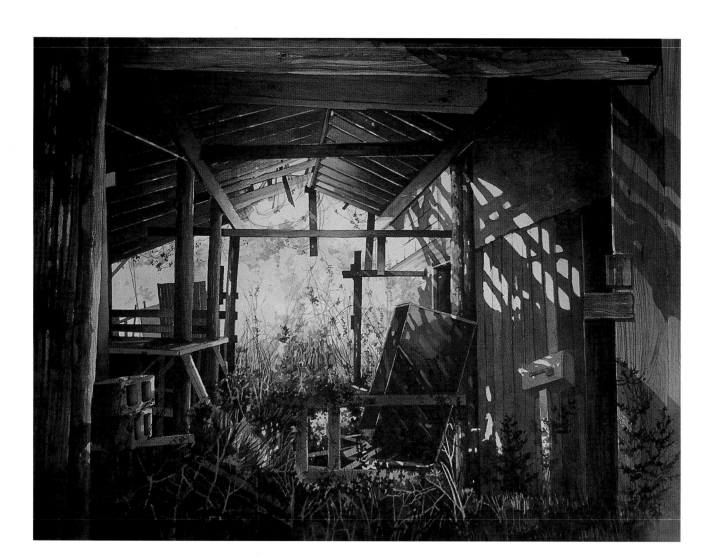

MAX MULLER
Abandoned
22" x 30" (56 cm x 76 cm)
Arches 300 lb. cold press rough

The interplay of light against dark in *Abandoned* creates the feeling of drama, mystery, and depth. Color values create the illusion of the third dimension. Shadow is the center of focus in this painting, and transforms a simple subject into a powerful and interesting work. The depth of color was accomplished by glazing color over color until the desired value was attained. Choice of a subject is not as important as technique, presentation, and control of the medium. I choose materials for their quality since quality products give me a definite edge.

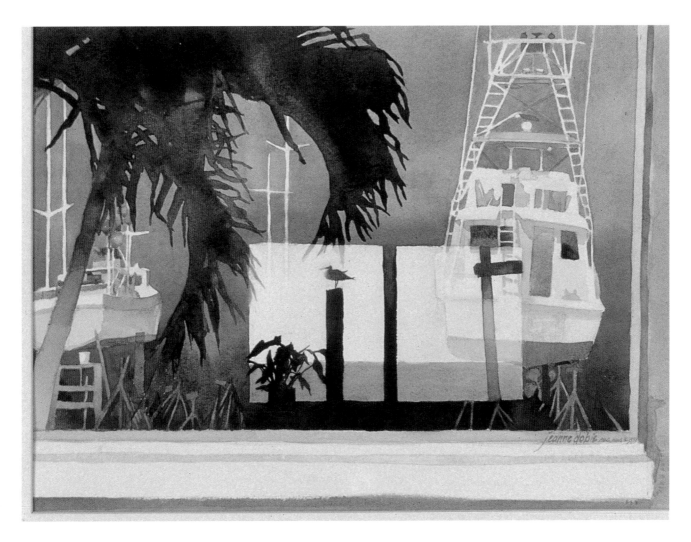

JEANNE DOBIE
Wish You Were Here
11" x 15" (28 cm x 38 cm)
Arches 140 lb. cold press

For personalized color, I mix pigments rather than using color straight from a tube. I want viewers to wonder what the color is instead of being able to name the pigments in my paintings. As a juror, I have yearned to see paintings with color that stood out from the crowd as I viewed endless entries painted with Paynes-gray hills, Hooker-green trees, and burnt-sienna fields. For *Wish You Were Here*, I mixed saturated colors for darks to obtain a stained-glass effect. Composing with custom colors can elevate an ordinary subject into an extraordinary painting.

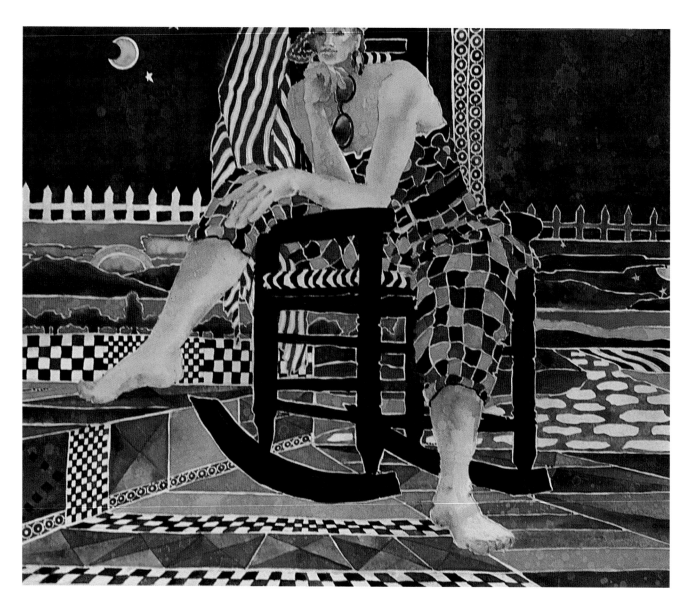

BARBARA A. ST. DENIS
Ecstasy I
15" x 20" (38 cm x 51 cm)
Arches 140 lb. cold press

Color and design are the most important aspects of my creative process and I experiment with color placement for drama and excitement. My daughter, Jacquie, is my inspiration and the central figure in most of my work. I change her face and distort her figure depending on the mood I wish to portray. Although I might start with a preconceived idea, I often change mid-stream. It is important that my work is not visually overpowered by the technique I may have used to create it, instead, I want the viewer to respond to color, content, and design.

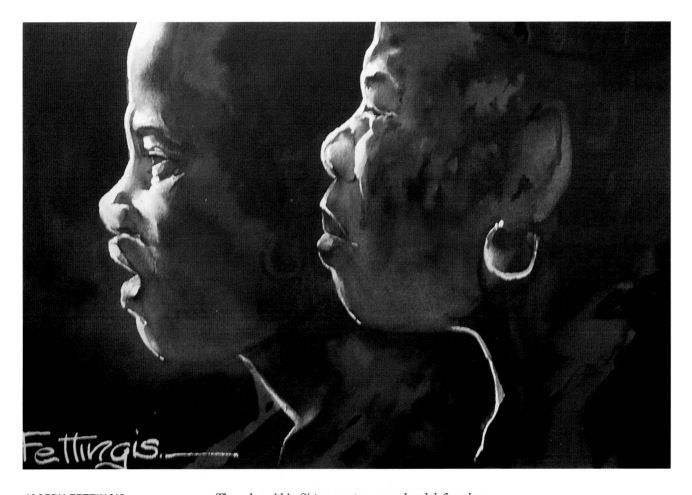

JOSEPH FETTINGIS
Sisters
18" x 24" (46 cm x 61 cm)
Arches 300 lb. hot press

The color within *Sisters* creates a mood and defines how light shapes the two main subjects. Massive amounts of color were used to get away from detail and evoke emotion by using raw, simple colors. After a careful rendering of the placement of the figures, masking was applied to save the whites. Violets, thalo green, sepia, and ultramarine blue were painted on a wet surface until the shine of the paper was almost gone, then cobalt blue was dropped onto the dark areas so it sat on top, creating free-flowing forms. Once dry, masking was removed and warm, rich golden colors were applied.

DALE ENGLISH
Monterey Cannery—Our
Colorful Past
22" x 30" (56 cm x 76 cm)
Arches 300 lb. cold press

As a plein air painter, I enjoy partici-
pating in what nature has to offer.
Surrounded by heavy early-morning
fog, I had to sit close to the subject
to better study it. At this close-up
perspective, I was impressed with
the angles and strong upward thrust
of the weathered gray structure.
Thoroughly soaking the paper, I
laid in a raw sienna wash, and the
pigment fell into crevices of the
folded paper, creating the direc-
tional movement I wanted.

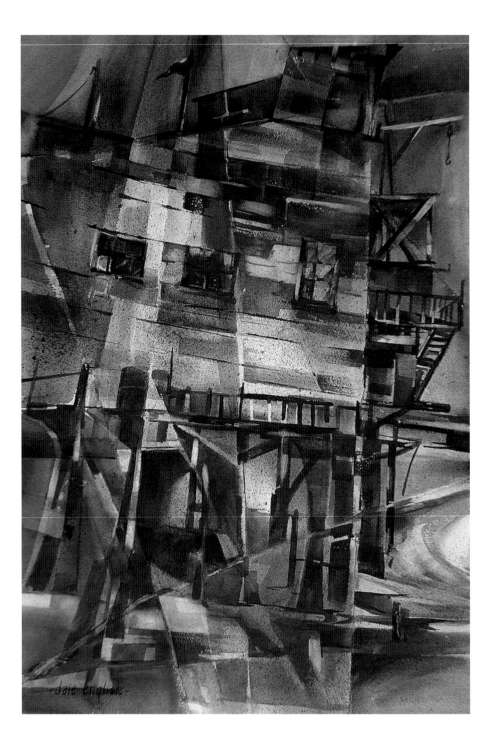

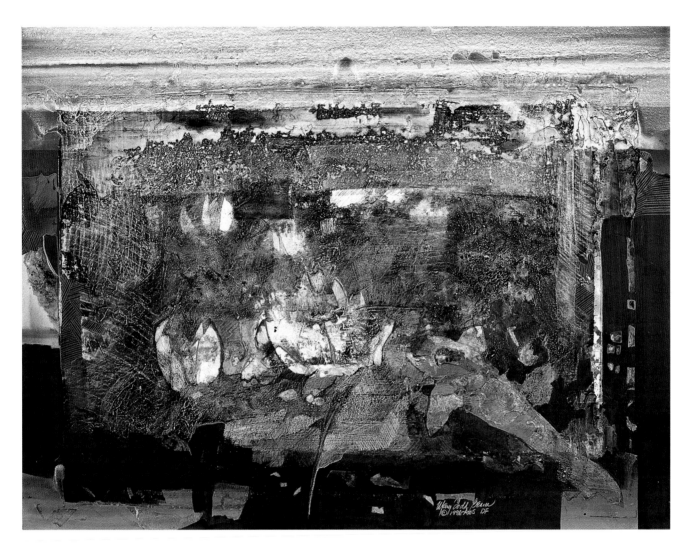

MARY TODD BEAM
The Quest
30" x 40" (76 cm x 102 cm)
Crescent illustration board
Watercolor with acrylic, colored
pencil, and gesso

Employing several improvisational techniques in *The Quest*, I started with a rich, dark underpainting and used a large gesso wash over part of the surface. I mixed some fluid acrylics with gesso to make an opaque paint to develop an esthetic contrast between the transparent and opaque colors and areas. Plastic cutouts were applied upon the wet paint to delineate the lilies and fish. Colored pencils enhanced the details and added interest to the surface texture. Opaque paint was also used to define figures and create some breathing space between the busy patterns.

MARY BARTON
Ladies of Brittany
30" x 22" (76 cm x 56 cm)
Arches 300 lb. cold press

Ladies of Brittany was designed around the interplay of small, warm patterns against cool, large shapes. The complementary color harmony of dominant blues with soft orange accents strengthens this contrast. Against the saved whites of the paper, subtle golden tints create a pathway of light leading the viewer into the work. Selective placement of color builds a strong value and color plan. Luminous dark blues tie the shapes together, provide stability, and unify the composition. Hard, soft, and lost edges, wet-in-wet washes, spatters, and value gradations are techniques used to describe and add interest.

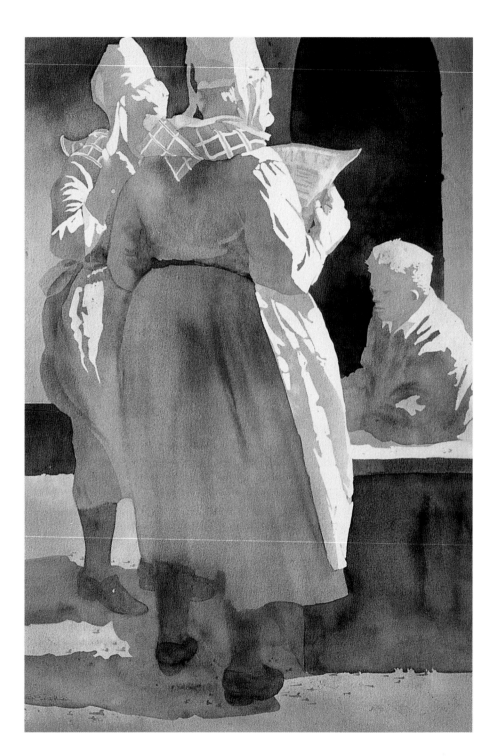

JOHNNIE CROSBY
Indian Ruins—Canyon de Chelle
15" x 22" (38 cm x 60 cm)
Arches 140 lb.

Strong sunlight reflecting on ruins gave depth to the dark cave background. I selected warm, bright tones to set the buildings off, making the painting more vibrant and emphasizing the warm, sunny atmosphere. Red and orange mixes were used for the interior of the cave which shelters these ancient buildings. This area of the canyon had a mystique about it, as though many important events had happened here in the past. I used a wet-in-wet technique to convey the feeling of a simple, contented existence.

GAYLE DENINGTON-ANDERSON
Great Jade Temple of the Golden Thistle Pagoda
22" x 15" (56 cm x 38 cm)
Arches 140 lb. rough
Watercolor and silver powder

Many of my works are inspired by the patterns in cut slabs of agate that seem to act as psychological inkblots. The hues in this painting are faithful to the rock slab, and the pinks and golds took on an Oriental cast. I increased the value contrast, darkening the gray-blue background where storm clouds seemed to arise. Very diluted alizarin and yellow ocher were used for the central figures. I wanted high-contrast and complementary colors to reflect the mythic dichotomy the work suggested. Metallic powder was added in the grayed background to suggest the treatment of a religious icon.

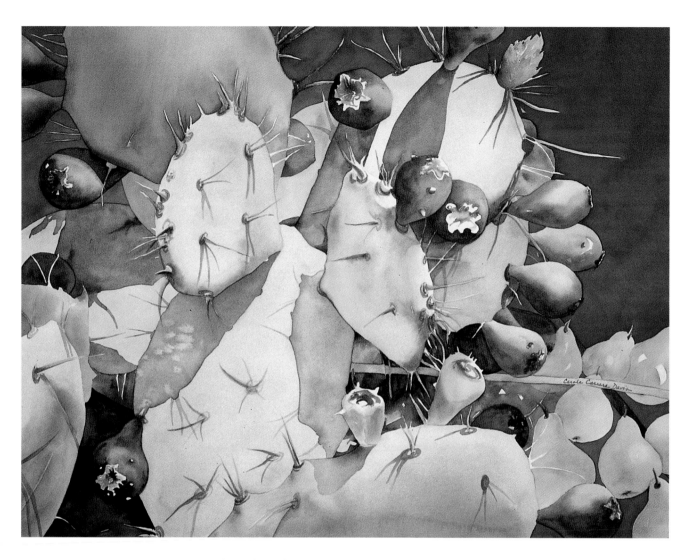

CAROLE C. DAVIS
Move Over Bartletts: The Prickley Pears are Ripe II
22" x 30" (56 cm x 76 cm)
Arches 140 lb. cold press

I have always been attracted to bright, vivid colors, and by choosing subjects bathed in sunlight, I can exaggerate and intensify colors. These bright red and yellow pears are especially vibrant when presented against an intense blue sky. Arches 140 lb. cold-press paper allows me the freedom to glaze many layers while maintaining a satin-like look to the surfaces of both fruit and cactus ears. Minimal use of coarse salt and a splatter of water provided needed texture on a cactus ear during the final glazing process. Reflected reds in the cast shadows add excitement and help integrate color.

LINDA BANKS ORD
Young Woman Series, #11
30" x 22" (76 cm x 56 cm)
140 lb. cold press
Watercolor with gouache and acrylic

I find when painting a work that is about color, such as *Young Woman Series, #11*, I actually use fewer colors than in other works. I choose my colors more carefully and use more variations of those colors. I layered opaque colors over an underpainting of contrasting transparent colors, moving color themes and rhythms through the painting. Working vertically on an easel, I mixed colors directly on the paper allowing individual colors to leave traces in the mixtures as they flowed downward.

SANDRA J. CAMP
Artichokes
18.5" x 21.5" (47 cm x 55 cm)
Arches 140 lb.

The challenge of unifying a complex subject with a diverse background led me to select artichokes. I glazed blues over yellows and kept building until I felt each artichoke achieved its own character and volume. Masking fluid was used to emphasize the design on the bowl, but was removed after the first wash was applied. Additional glazing softened the design so the bowl would complement, rather than compete with, the artichokes. By using the analogous colors of blue, green, and yellow in a mid-value range, the painting conveys a feeling of tranquillity and unity.

JACQUELYN FLEMING
California Impressions
15" x 21" (38 cm x 53 cm)
Arches 140 lb. cold press
Watercolor with acrylic

Color is the element of painting that stimulates my enthusiasm and creativity. In *California Impressions*, subject matter was not apparent until I turned the paper around and it reminded me of a California landscape with its varied and changing colors. Working with acrylics let me paint freely and spontaneously; I tried to capture the warmth and vibrancy of the colors while retaining patterns and values. While I have been a realist throughout my painting career, I have had periods of working intuitively, and this work is an example of that process.

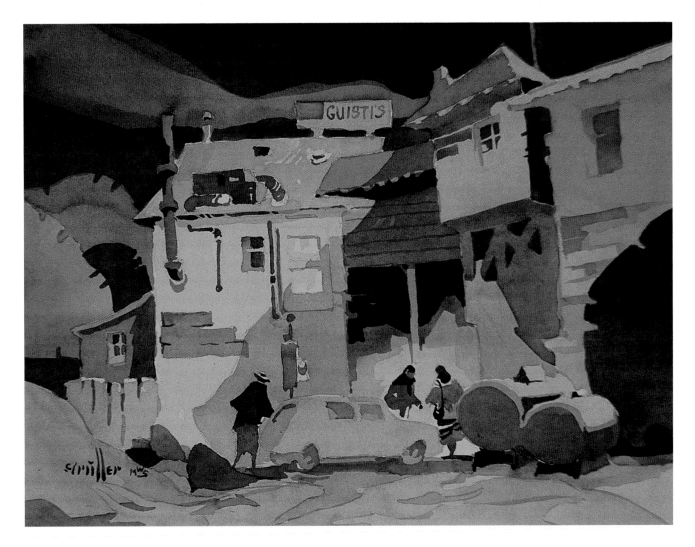

CARL VOSBURGH MILLER
Guisti's Place
11" x 15" (28 cm x 38 cm)
Arches 140 lb. cold press

I have painted Guisti's often and am attracted to its shapes and colors. Muted earth tones were chosen to best convey my feelings. The parts fit together to make a visual abstract pattern like a giant puzzle, with warm tones played against cool colors. People in the foreground become color notes which provide accents. When the sunlight is strong, the deep shaded areas hide details of the structure and simplify the overall design. It is this jigsaw effect that draws me to return and paint it again.

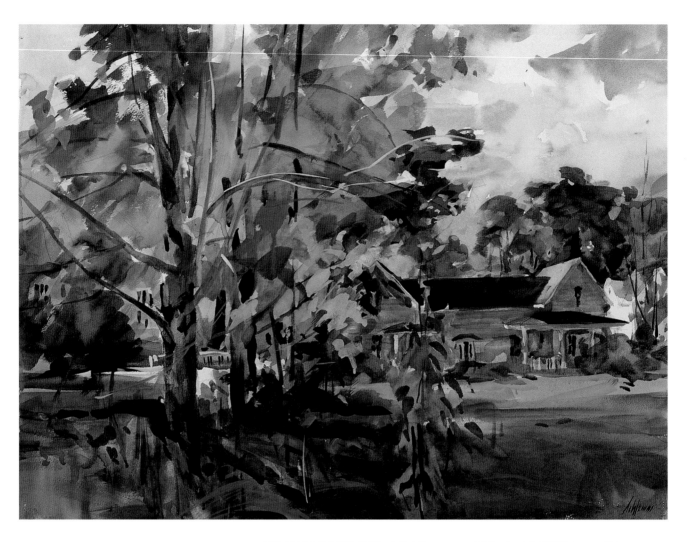

about the authors

BETTY LOU SCHLEMM
Thomaston, Maine
22" x 30" (56 cm x 76 cm)

BETTY LOU SCHLEMM, *JUDGE*

Betty Lou Schlemm, A.W.S., D.F., has been painting for more than thirty years. Elected to the American Watercolor Society in 1964, and later elected to the Dolphin Fellowship, she has served as both regional vice president and director of the American Watercolor Society. Schlemm is also a teacher and an author. She has been conducting painting workshops in Rockport, Massachusetts for twenty-nine years. Her book, *Painting with Light*, published by Watson-Guptill in 1978, has remained a classic. She also has recently published *Watercolor Secrets for Painting Light*, distributed by North Light Books, Cincinnati.

SARA M. DOHERTY, *EDITOR*

Sara M. Doherty graduated from Knox College in Galesburg, Illinois and took graduate-level courses in education at Loyola University in Chicago. She has been a teacher and a learning center director, and she has helped organize a number of national art competitions, juried exhibitions, and painting workshops. She also worked on the production and sale of an art instruction video with the noted watercolorist, Sondra Freckelton. In 1994, Doherty accompanied a group of artists and art lovers to Italy and reported on the workshop in an article published in *American Artists* magazine.

directory of artists

Jon D. Arfstrom 90
3275 Lake Johanna Boulevard
St. Paul, MN 55712

Carmen Newman Bammert 65
9116 Buffalo Court
Flushing, MI 48433

Leslie Rhae Barber 111
1870 Evening Star Drive
Park City, UT 84060

Charles F. Barnard 106
4740 North Kelsey Place
Stockton, CA 95207

Mary Barton 130
P.O. Box 23133
Waco, TX 76702-3133

Miles G. Batt, Sr. 70
301 Riverland Road
Ft. Lauderdale, FL 33312

Mary Todd Beam 129
125 Cricket Hollow Way
Crosby, TN 37722

Mary Jane Bell 82
1018 D 42nd Street South
Birmingham, AL 35222

Donne F. Bitner 51
449 Blakey Boulevard
Cocoa Beach, FL 32931

Marilyn Sears Bourbon 76
16765 Oak View Circle
Morgan Hill, CA 95037

Jorge Bowenforbes, A.W.S., N.W.S. 24
P.O. Box 1821
Oakland, CA 94612

Charlotte Britton, A.W.S., N.W.S. 19
2300 Alva Avenue
El Cerrito, CA 94530

Dan Burt, A.W.S., N.W.S. 53
2110 B West Lane
Kerrville, TX 78028-3838

Ralph Bush 79
55 Mt. Pleasant Street
Rockport, MA 01966

Barbara George Cain 71
11617 Blue Creek Drive
Aledo, TX 76008

Sandra J. Camp 135
463 West Street
Amherst, MA 01002

Todd Chalk 43, 44
4150 South Harris Hill Road
Williamsville, NY 14221

Allison Christie 37
521 Spring Valley Road, NW
Atlanta, GA 30318-2640

Celia Clark 26
R.D. 2, Box 228 A
Delhi, NY 13753

Dede Coover 40
3008 Twin Oak Road
Cameron Park, CA 95682

Johnnie Crosby 131
17460 Cedar Lake Circle
Northville, MI 48167

Connie Cuthbertson 107
Box 587
International Falls, MN 56649

Mickey Daniels 25
4010 East San Juan Avenue
Phoenix, AZ 85018

Ratindra Das 93
1938 Berkshire Place
Wheaton, IL 60187

Carole C. Davis 133
567 Hickory Hill Circle
Blacksburg, VA 24060

Gayle Denington-Anderson 132
661 South Ridge East
Geneva, OH 44041

Lorraine Denzler 21
36728 32nd South
Auburn, WA 98001

Don Dernovich, N.W.S. 92
Box 163 - 210 Taylor
Culbertson, NE 69024

Joseph C. DiBella 108
205 Breezewood Drive
Fredericksburg, VA 22407

Henry W. Dixon, N.W.S., K.W.S. 46
8000 East 118th Terrace
Kansas City, MO 64134

Jeanne Dobie, A.W.S., N.W.S. 125
160 Hunt Valley Circle
Berwyn, PA 19312

Donald L. Dodrill 88
17 Aldrich Road, Suite C
Columbus, OH 43214

Brian Donn 9
3364 Boundary Street
San Diego, CA 92104

Evalyn J. Dyer 72
6041 Worrel Drive
Ft. Worth, TX 76133

Dale English 128
2023 East Sims Way #182
Port Townsend, WA 98368

Ruth L. Erlich 78
161 Tigertail Road
Los Angeles, CA 90049-2705

Rich Ernsting 122
6024 Birchwood Avenue
Indianapolis, IN 46220

Nancy Feldkamp 8
8701 Smyth Road
Manchester, MI 48158

Joseph Fettingis 127
Lakeview Studio
625 Lakeview Drive
Logansport, IN 46947

Jacquelyn Fleming 136
36838 Woodingham Drive
Clinton Township, MI 48035

Jack Flynn, A.W.S. 94
3605 Addison Street
Virginia Beach, VA 23462

Janet J. Ford 123
7386 Roxbury Avenue
Manassas, VA 20109

Gwen Fox 103
2017 Brookwood Drive
Colorado Springs, CO 80918

Tom Francesconi 98
2925 Birch Road
Homewood, IL 60430

Frank Francese, N.W.S. 96
1771 Stellar Place
Montrose, CO 81401

Jane Frey 36
518 West Franklin
Taylorville, IL 62568

Marsha Gegerson 42
10241 Northwest 48 Court
Coral Springs, FL 33076

Millie Gift 117
706 Fernwood
Jackson, MI 49203

Harriet Marshall Goode 35
844 Myrtle Drive
Rock Hill, SC 29730

Irwin Greenberg 7
17 West 67th Street
New York, New York 10023

Dorothy D. Greene 118
6500 Southwest 128th Street
Miami, FL 33156

Geraldine Greene 39
102 Plantation Boulevard
Islamorada, FL 33036

Jeannie Grisham, N.W.W.S., N.W.S. 119
10044 Edgecombe Place NE
Bainbridge Island, WA 98110

Sheila T. Grodsky 91
940 West End Drive
Newton, NJ 07860

Marilyn Gross 68
374 MacEwen Drive
Osprey, FL 34229

Linda S. Gunn 32
5209 Hanbury Street
Long Beach, CA 90808

Sharon Hildebrand 20
5959 St. Fillans Court W
Dublin, OH 43017

Jane R. Hofstetter, N.W.S. 61
308 Dawson Drive
Santa Clara, CA 95051

Mary Sorrows Hughes 58
1045 Erie Street
Shreveport, LA 71106

Angelis Jackowski 116
2556 Breckenridge Drive
Ann Arbor, MI 48103

Kathleen Jardine 64
470 Tanager Lane
Chapel Hill, NC 27514

Jane E. Jones 63
5914 Bent Trail
Dallas, TX 75248

Lola Juris 14, 15
3200 Buena Hills Drive
Oceanside, CA 92056-3942

Joyce H. Kamikura, F.C.A., N.W.S. 48
6651 Whiteoak Drive,
Richmond, BC V7E 4Z7
Canada

Nordia Kay 56
145 Humphrey Street
Marblehead, MA 01945

Sue Kemp, S.W.S., T.W.S. 97
8102 Greenslope Drive
Austin, TX 78759

Judith Klausenstock 45
94 Reed Ranch Road
Tiburon, CA 94920

George W. Kleopfer, Jr. 29
2110 Briarwood Boulevard
Arlington, TX 76013

James L. Koevenig 41
845 Keystone Circle
Oviedo, FL 32765

Fredrick Kubitz, A.W.S., N.E.W.S. 10
12 Kenilworth Circle
Wellesley, MA 02181

Gertrude Lacy 18
200 Fiddletop Lane
Covington, VA 24426

Janet Laird-Lagassee 13
43 Elmwood Road
Auburn, ME 04210

Hal Lambert 86
32071 P.C.H.
South Laguna, CA 92677

Robert Lamell, K.A., N.W.O. 69
2640 West Wilshire Boulevard
Oklahoma City, OK 73116

Douglas Lew 33
4382 Browndale Avenue
Edina, MN 55424

George S. Loli 110
116 St. Julien Avenue
Lafayette, LA 70506

Steven Lotysz 87
847 Overlook Court West
Frankfort, IL 60423

Susan Luzier 100
1429 South 3rd Street
Aberdeen, SD 57401

Mary Britten Lynch 85
1505 Woodnymph Trail
Lookout Mountain, GA 30750

David Maddern 28
6492 Southwest 22nd Street
Miami, FL 33155-1945

Margaret M. Martin, A.W.S. 57
69 Elmwood Avenue
Buffalo, NY 14201

Karen Mathis 60
9400 Turnberry Drive
Potomac, MD 20854

Benjamin Mau, N.W.S. 62
1 Lateer Drive
Normal, IL 61761

Frances H. McIlvain 47
40 Whitman Drive
Red Bank, NJ 07701

Joanna Mersereau 30
4290 University Avenue
Riverside, CA 92501-3142

Fred Messersmith 121
726 North Boston Avenue
Deland, FL 32724

Carl Vosburgh Miller 137
334 Paragon Avenue
Stockton, CA 95210

Edward Minchin 120
54 Emerson Street
Rockland, MA 02370

Max Muller 124
6902 Stetson Street Circle
Sarasota, FL 34243

Ellen Negley 84
824 Forest Hill Boulevard
West Palm Beach, FL 33405

Paul W. Niemiec, Jr. 73
P.O. Box 674
Baldwinsville, NY 13027

Michael L. Nicholson 54
255 South Brookside Drive
Wichita, KS 67218

Diane J. O'Brien 112
17135 Beverly Drive
Eden Prairie, MN 55347

Robert S. Oliver, A.W.S., N.W.S. 38
4111 East San Miguel
Phoenix, AZ 85018

Don O'Neill, A.W.S. 89
3723 Tibbetts Street
Riverside, CA 92506

Linda Banks Ord 134
11 Emerald Glen
Laguna Niguel, CA 92677

Gloria Paterson, N.W.S., 152
9090 Barnstaple Lane
Jacksonville, FL 32257

Joyce F. Patrick 34
P.O. Box 9347
Rancho Santa Fe, CA 92067

Ann Pember 59
14 Water Edge Road
Keeseville, NY 12944

Jim Pittman 12
Box 430
Wakefield, VA 23888

Patricia Reynolds, M.W.S .11
390 Point Road
Willsboro, NY 12996

Leatrice Joy Richardson 102
3923 Clearford Court
Westlake Village, CA 91361

Jerry Rose 113, 114
700 Southwest 31st Street
Palm City, FL 34990

Raka Bose Saha 66
1485 Country Lake Drive
Lilburn, GA 30247

Barbara A. St. Denis 126
196 Doberman Trail
Easley, SC 29640

Sandra Saitto 3, 115
61 Carmel Lane
Feeding Hills, MA 01030

J. Luray Schaffner 77
14727 Chermoore Drive
Chesterfield, MO 63017-7901

Richard Seddon 74
6 Arlesey Close
Lytton Grove
London, SW15 2EX
United Kingdom

Janet Shaffer 75
11037 Timberlake Road
Lynchburg, VA 24502

Lois Showalter 101
231 R Granite Street
Rockport, MA 01966

Delda Skinner 31
8111 Doe Meadow Drive
Austin, TX 78749

Wayne H. Skyler 55
20 Hickory Drive
Stanhope, NJ 07874

Penny Stewart 6
6860 Cedar Ridge Court
Colorado Springs, CO 80919

Caleb Stone 104
45 Washington Street #3
Methuen, MA 01844

Jane Talley 49
8255 Carrick
Fort Worth, TX 76116

Dean Teague 105
P.O. Box 96
Mount Vernon, TX 75457

Nedra Tornay 67
2131 Salt Air Drive
Santa Ana, CA 92705

Judy D. Treman 95
1981 Russell Creek Road
Walla Walla, WA 99362

Christine M. Unwin 27
6850 Brookeshire Drive
West Bloomfield, MI 48322

Jan Upp 16, 17
7335 Shadbleau
Jenison, MI 49428

Veloy J. Vigil 99
224 North Guadalupe
Santa Fe, NM 87501

Harold Walkup 80
5605 Southwest Rockwood Court
Beaverton, OR 97007

Janet B. Walsh 109
130 West 80th Street
New York, NY 10024

Wolodimira Vera Wasiczko 81
5 Young's Drive
Flemington, NJ 08822

Elaine Weiner-Reed 50
1309 Bernie Ruth Lane
Severn, MD 21144

Genie Marshall Wilder 83
102 Horseshoe Lane
Clinton, SC 29325

Yvonne Wood 22, 23
3 Babcock Road
Rockport, MA 01966

glossary

analogous colors: the shades, tints, or tones of any three colors that are next to each other on the color wheel

background: the part of the painting that appears to be farthest from the viewer

balance: the even distribution of shapes and colors in a painting

bristol board: a stiff, durable cardboard made in plate and vellum finishes with thicknesses of one- to four-plies

cold-press paper: paper with a medium-rough texture as a result of being pressed with cold weights during processing

collage: process of constructing flat (or low relief) two-dimensional art by gluing various materials (i.e. photographs news-paper, etc.) onto the painting surface

complementary colors: any two colors that are opposite each other on the color wheel (i.e., red and green) which create a high contrast when place side by side

contrast: the juxtaposition of extremes within the composition—in colors (purple with orange), values (white with black), textures (coarse with smooth), etc.

crayon resist: a technique in which crayon is applied to the surface and repels the paint that is applied afterward

crosshatching: brushstrokes applied at right angles to each other to create contrasting tone and density

dapple: to mark or patch with different shades of color

drybrush: a method of painting in which most of the pigment has been removed from the brush before application

foreground: the part of the painting that appears to be closest to the viewer

gesso: a paste prepared by mixing whiting with size or glue and spread upon a surface to fit it for painting or gilding

gouache: a method of painting with opaque colors that have been ground in water and mingled with a preparation of gum

hot-press paper: paper with a smooth surface as a result of being pressed between calendar rollers that flatten the grain into an even finish

hue: the actual color of anything—also used to describe what direction a color leans toward, (i.e. bluish-green, etc.)

illustration board: layers of paper adhered to a cardboard backing to produce a sturdy drawing surface, made in various thicknesses and textures

local color: the true color of an object seen in ordinary daylight

museum board: available in two- and four-ply, this soft, textured surface absorbs wet or dry pigment readily; usually used in archival matting and framing of artwork

saturation: the intensity or brightness of color

shade: the color achieved when black is added to a hue

spatter: to scatter color on the canvas by splashing on paint

stipple: to create an optical mix of colors through the use of dots or dashes

tint: color achieved when white or water is added to a hue

tooth: refers to the depth of the grain of paper

value: the relative lightness or darkness of a color

vellum: a smooth, cream-colored paper resembling calfskin

wash: a thin, usually transparent coat of paint loosely applied to the surface of the canvas